GHOSTS OF GRAND RAPIDS

NICOLE BRAY AND ROBERT DU SHANE WITH JULIE RATHSACK

Haunted America

Published by Haunted America
A Division of The History Press
Charleston, SC 29403
www.historypress.net

Cover photos courtesy of Bradley Donaldson.

First published 2013

Manufactured in the United States

ISBN 978.1.62619.205.8

Library of Congress CIP data applied for.

This book is dedicated to Julie. Your courage was incredible; the rewards for me are never-ending.
—Nicole Bray

Dedicated to my parents Gene and Vicki Krzeminski, for their endless support. And my three "bros": Dave, David and Sam Rathsack. I'd be lost without all of you!
—Julie Rathsack

To Mom. Your help over the last year has made it possible for me to get my life back. I love you.
—Reverend Robert Du Shane

CONTENTS

ACKNOWLEDGEMENTS

We would like to thank the following people and organizations for all of their help: Algoma Township Historical Society, Grand Rapids Public Museum and especially the Grand Rapids Public Library staff. Robert and Nicole would like to personally thank our family and friends for putting up with us. Julie would like to thank her sister, Heather Burke, whose input was invaluable. She also would like to thank her niece, Joey Anna Krzeminski, for reminding her how exciting ghosts can be!

INTRODUCTION

We all know that Grand Rapids is home to many ghosts. What most people do not know, however, is that tales of ghostly encounters, vanishings and other mysterious activities veiled the city of Grand Rapids, Michigan, long before it was officially established in 1850.

At the turn of the eighteenth century, the neighboring Native Americans labeled the land on which the city now sits, "the Haunted Valley of the Grand." They strongly believed that evil spirits roamed the entire area. It was not uncommon for individuals or occasionally entire hunting parties to vanish in the woods along the Grand River, many of them never to be seen or heard from again.

While the vast forests have been replaced over time with concrete, bricks and glass, many believe that the malicious ghosts experienced by the Native Americans still roam this land, wreaking havoc on the living.

Is the city of Grand Rapids cursed? Many people believe it is. After reading the following chapters, you can draw your own conclusion.

CHAPTER 1

BRIEF HISTORY OF GRAND RAPIDS

In order to appreciate the haunted side of Grand Rapids, it helps to know just what the land has been through. Grand Rapids has been home to many different people throughout its history. Settlers have long been drawn to the moderate climate, rich soil and vast supply of fresh water.

The first people to settle in this area laid their roots over ten thousand years ago. These settlers were a migratory people who followed the roaming mastodons and mammoths at the end of the last ice age. As the glaciers melted away, the climate started to become more inhabitable. The ice gave way to vast forests containing edible plants, small game and an abundance of fish.

Over 2,500 years ago, the Grand River Valley was occupied by Native Americans known to historians simply as the Mound Builder Indians because of the large mounds they left wherever they settled. The tribe had migrated to the area from the Mississippi River Valley. They traveled through Illinois and settled in Michigan as far north as the Muskegon River. The Mound Builders were a peaceful tribe and survived almost entirely by cultivating the land. Their presence is still evident today by the preserved mounds on the southwest side of Grand Rapids. Local historians theorize that the first major act of violence occurred in this area when another Native American tribe traveled down from the north and exterminated the Mound Builder Indians. Although no one is completely sure which tribe wiped them out, those who have examined Michigan's earliest written records believe it was the Sioux Indians.

Approximately three hundred years ago, the Ottawa Indians were forced west by the Iroquois and settled along the Grand River's edge. The Chippewa were just to the north, and the Pottawatomie were just south. These three tribes made up a group called the People of the Three Fires.

During the seventeenth and eighteenth centuries, as the Europeans and Americans struggled to control the area, the People of the Three Fires were often forced to choose sides during the battles, all the while trading furs for textiles, metals and other useful goods. In just two generations' time, control shifted from the French to the British and eventually to the Americans.

During this power struggle, the natives found their once lucrative fur trade becoming more restricted. What started as the open trade system used by the French transitioned to the British licensing system. Finally, the Americans took not only the furs but also the land occupied by the Ottawa Indians. By the beginning of the nineteenth century, the transition from Indian country to United States territory was complete. Between 1821 and 1836, a series of treaties were signed that extinguished the majority of all Indian claims to the land in Michigan. This was unfortunate for the natives as it left much of the state open to be snatched up by the often greedy and land-hungry settlers.

In 1825, Grand Rapids' first permanent resident, Isaac McCoy, set up a Baptist mission within the area known as the "Rapids of the Grand." He was soon followed by a Roman Catholic priest named Father Frederic Baraga, who established a Catholic mission nearby.

Other settlers came to the area in search of riches. Two of the best examples of these pioneers were Rix Robinson, an agent of the American Fur Company, and independent fur trader Louis Campau. Both of these men moved to the area in hopes of collecting pelts and opened trading posts to compete for the furs. Louis Campau was the victor and became known to the Ottawa tribe as "the Fox" due to his shrewd trading skills.

Campau had moved from his birthplace in Detroit in 1826 to establish his trading post along the east bank of the Grand River, where he also built a cabin and blacksmith shop. Louis Campau would later become known as the founder of Grand Rapids. His success as a trader allowed him to acquire a small fortune. In 1831, he purchased seventy-two acres from the federal government for ninety dollars. Campau named this village Grand Rapids. It is on this land that the entire downtown business district, bordered by the Grand River, Division Avenue, Fulton Street and Michigan Street, sits today. Not to be outdone, a local land surveyor named Lucius Lyon bought the land to the immediate north of Campau's land and named it the village of Kent.

The fallout from the feud between Campau and Lyon is still felt by local commuters to this day. Campau, who had an established relationship with the Ottawa tribe, laid out his main street Monroe Avenue along the principal Indian trail that led diagonally from the river to his trading post. Lyon, a surveyor, laid out his streets in the more generally accepted grid style with the streets running in the directions of a typical compass.

Louis Campau was against the two competing villages being connected. To prevent this from happening, he purchased a strip of land that was between the villages and refused to build on it. Eventually, Lyon was able to secure a small "canal" of land from Campau. This street would be appropriately named Canal Street, connecting the village of Kent to Monroe Avenue in Grand Rapids.

When it became evident to Lyon he would be unable to procure more of this coveted strip of land, he decided to get revenge on Campau. He bought a string of plots directly to the north of Campau's lots that prevented Campau from making any more expansions. Furthermore, it resulted in the modern downtown layout, where roads often meet at odd angles or, in some cases, not at all.

In 1836, the Michigan legislature officially created the Village of Grand Rapids. This new village used both men's plats. The town was roughly bordered by Hastings Street to the north, Prospect Avenue on the east, Fulton Street on the south and the Grand River to the west. Campau was on the first board of trustees and one of seven men who named Henry C. Smith the village's first president.

By the time Grand Rapids was incorporated on April 2, 1850, it was well on its way to becoming the furniture city. It already had one furniture factory and several small private shops that created various furniture pieces. The city's location on the Grand River made it the ideal place to manufacture furniture. Locals were able to use the Grand River to generate power for the factory. Furthermore, the proximity to the river made it easy to float logs from the lush forests located upstream. These forests were an excellent source for both the hard and soft woods needed to support the furniture industry.

By 1857, the city had already grown from approximately four square miles to over ten square miles. Over the next century, the city would continue to thrive. Gypsum mining and furniture factories provided many jobs that brought new people to the area. Hotels and boardinghouses popped up all over the city. Department stores like Steketee's, founded in 1862, became the city's retail hub. After an international exhibition in Philadelphia in 1876,

the city of Grand Rapids became recognized worldwide as a leader in the production of fine furniture.

Today, Grand Rapids is known as "Furniture City" and is considered the world's leader in the production of office furniture. It is also recognized as the hometown and final resting place of Gerald R. Ford, the thirty-eighth president of the United States. It is no wonder that a city with such a long history has also given birth to so many ghost stories.

CHAPTER 2

GRAND RAPIDS' BEST-KNOWN GHOST STORY

Location: Corner of Fountain Street and Division Avenue in Downtown Grand Rapids

T he most prevalent ghost legend in our great city would have to be the story of the Michigan Bell Building and of Warren and Virginia Randall. The late Don W. Farrant, the original author of *Haunted Houses of Grand Rapids*, first introduced the ghostly tale to the public in 1979. Since then, paranormal enthusiasts have continuously looked at the old Michigan Bell Building, which is now the AT&T Building, with an almost unequivocal level of awe and curiosity.

A majority of the citizens who live in Grand Rapids that have heard this story believe it is nothing more than an urban legend. I felt the same way until finding a news article that would forever change my view on the topic.

Let's begin by recounting the story of this grisly murder/suicide as most of the paranormal world knows it.

LEGEND OF THE WOODEN LEG MURDER

In 1907, Warren Randall and his wife, Virginia, moved from Detroit to Grand Rapids. Warren worked as a brakeman for the Grand Rapids and Indiana Railroad. The couple took up residence in the historical Judd-White House. The dwelling was named for its original owners, Mayor George White and his daughter, Mrs. Charles B. Judd. Both lived in the home shortly after the

Civil War. By the turn of the century, the Judd-White House had been made into a rental property; it was during this time that the Warrens moved in.

The three years that the couple spent in this house were filled with turbulence and stress. Believing that his wife was having several affairs with local men, Warren would sometimes turn violent. Neighbors informed the police of such an incident when they saw Warren chase his wife down an alley with a straight razor in his hand. By mid-August of 1910, the couple separated and the former rooming house sat vacant.

On the evening of August 26, perhaps with the idea that the two could talk of reconciliation, Warren asked Virginia to join him for a carriage ride. The couple rented a rig from the Morton House Livery. Unfortunately for Virginia, instead of heading out for a trip filled with romance, he took her back to the house on the corner of Fountain Street and Division Avenue. Warren persuaded her to enter the house, where they wound up in their former bedroom.

Warren's true intentions on that fateful night will never be known. Perhaps the tragedy began as an intimate escapade that ended disastrously when something sent Warren into a jealous rage. Perhaps Virginia was not interested in Warren's advances and demanded they leave the house. What transpired in the final moments of this star-crossed couple will never be known. What we do know is, while withering away in madness, Warren decided the best course of action that night was to end his life and the life of his beloved Virginia.

The legend goes that while in the bedroom, he removed his wooden leg and used it to deliver a massive blow to the back of Virginia's head. With Virginia sprawled out on the bed, blood flowing out of her head and spilling onto the floor, Warren darted through the house, locking all the doors and windows. He then returned to the bedroom, where he locked himself inside and began sealing all the crevices. Once he completed that task, he hastily removed a gas fixture from the wall, allowing the toxic fumes to flow freely into the room, creating his own homemade gas chamber.

Further illustrating his deranged state, Warren attempted suicide by slashing his throat with a straight razor. Ironically, it is believed this was the very razor he used to chase Virginia with several days prior to her murder. The slash to his neck was only superficial. Either Warren was inept with this deadly weapon, or he simply lost his courage while administering what was intended to be a much deeper cut to his throat.

Because the Judd-White House was believed to be vacant, the incident went undiscovered for close to two weeks. Tenants from a neighboring

building began to complain about a horrible odor that was making some of them ill. The Department of Health was eventually notified, and two agents were sent to check out the tenants' claims. The smell only got worse as they approached the building. When the front door was torn down, the men were immediately assaulted by gas fumes mixed with the sickly stench of decomposition.

Inspecting the rest of the house, officials broke into the sealed bedroom and found the horrifying sight of two blackened bodies lying on the bed. Both had been exposed to gas fumes for days, making them unrecognizable. The couple would have gone unidentified if it hadn't been for Warren's wooden leg.

The bodies of Warren and Virginia Randall were removed, and the Judd-White House remained vacant for decades, but not before becoming the catalyst for the most peculiar haunting in Grand Rapids' history.

Dozens of people, with occupations ranging from investigators to journalists, have scoured through decades of records in hopes of finding the truth behind this horrific tale. Looking through census records from 1910, I couldn't find a Warren or Virginia Randall living in the city of Grand

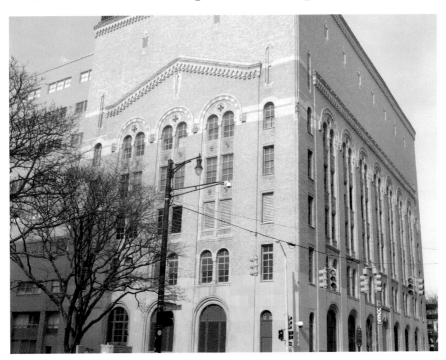

AT&T Building. *Photograph by Robert Du Shane, 2011.*

Rapids, there was no employee named Warren Randall with the Grand Rapids and Indiana Railroad Company and the date of the supposed *Grand Rapids Press* article featured no mention of this macabre incident. It looked as though this fabulous ghost story was nothing more than that—a story.

I contacted Gary Eberle, the author who revised the *Haunted Houses of Grand Rapids* book in 1994. He informed me that when Don W. Farrant sold him all the records and copyright to the book for future publication, there were research records and testimonies backing up every story from the original book—every story except for one: the Michigan Bell Building.

THE TRUTH BEHIND THE LEGEND

The story of the Randalls continued to be a local myth in my mind until the fall of 2010. It was at this time that I came across the missing piece of the puzzle; the evidence to unlock a story that has mystified Michiganders for over one hundred years. It was nothing more than a small newspaper clipping, but it brought chills to think that I had finally found the origin of the now infamous tale. Blatantly obvious was the fact that the names and dates had been changed. This would explain why it had been so difficult for anyone to substantiate the details of this account.

The real story behind the legend began when Warren Rowland traveled from his hometown of Oakland, California, to Grand Rapids, Michigan, with plans to begin a new life. He had a job working as a switchman for the Grand Rapids and Indiana Railroad Company until tragedy struck on December 2, 1907. It was during this night that Warren fell under the wheels of a train, crushing his foot above the ankle. He was brought to Saint Mary's Hospital, where his lower leg was amputated. The accident left him with a wooden leg and a new, unfulfilling job. Although still employed by the railroad, he was forced to work in the office as a billing clerk.

While living in Michigan, he met a young woman from Detroit named Vashti Perry. The two of them soon married against her parents' wishes. After they wed, they found it difficult to keep a home for any length of time and resided in many houses throughout the city. Among the many addresses they shared were 146 East Bridge Street and 208 Third Avenue. Eventually, they rented the house at 74 North Division Avenue from C.B. Judd. The house had been vacant since the death of Judd's mother-in-law in 1907.

Their marriage, according to family members and neighbors, was nothing short of stormy. Mrs. DeWitt, a former neighbor who resided at 86 North

Division, told the local police and the *Grand Rapids Herald* that she frequently heard Mrs. Rowland screaming in the house. Mrs. DeWitt had numerous conversations with Vashti, who confided in her that Warren had threatened to kill her many times. Vashti also revealed that she had plans to leave Warren and open a boardinghouse back in Detroit.

Warren was also unhappy in the marriage, as evidenced by the bill of divorce that his attorney, William B. Brown, filed against Vashti early in 1909. He charged that she was "often in the company of improper associates, drank heavily, and refused to stay home or prepare his meals."

The following day, Mrs. Rowland filed a cross-motion of divorce through the law offices of Knight & MacAllister. In addition, she requested an injunction to restrain her husband from injuring her, an equivalent to today's personal protection order (PPO). It was soon clear that her fear of physical retribution was well founded; the day after the injunction was filed, their paths crossed on the street. With a blatant disregard for the court order, Warren knocked her down and kicked her.

Only one week prior to the murder, Warren entered his attorney's office in a "cheerful frame of mind." He informed his attorney that he and his wife had worked things out and decided to give the marriage another try. The attorney simply congratulated Warren and sent him on his way, without a single thought to the actual motive behind his sudden intentions of reconciliation. As he reflected on that day, after learning of the Rowlands' demise, he was quoted in the *Grand Rapids Herald* as saying, "I suppose they got together to make up that Saturday and had another quarrel in the evening, which resulted fatally."

On the evening of Saturday, June 26, Warren Rowland and his wife, Vashti Perry-Rowland, rented a buggy from the Morton House Livery. Witnesses that knew of the couple's troubled marriage reported later to the media that they were stunned to see Vashti agree to a carriage ride with Warren. It was a well-known fact that she was afraid of her husband. Irving Woodworth, who was working at the livery during the time of Rowland's rental, would later report that Vashti did not seem to be under any duress. In any case, when the Rowlands left the livery that night, it was the last time anyone would see them together alive.

Vashti's younger brother Louis Perry and his sister Hazel had been hunting for their sister and could not locate her. The following Monday, they went to the livery to inquire about the Rowland's trip. They were told that Warren had returned alone with the rig around 11:15 p.m. the same night. He was last spotted around 11:45 p.m. between Monroe Avenue and

Commerce Avenue. Later that day, Hazel notified the local police of the disappearance of her sister and brother-in-law. She was told, however, that the police could do nothing to help her. As the days went by with no word from Vashti, Hazel continued to make pleas to the police department for help; these pleas seemed to fall on deaf ears.

Several days later, Mrs. DeWitt reported to friends that she had noticed an overpowering odor coming from the house on the corner. She had intended to visit the home to pin down the cause of the smell but never got around to it. She surmised that the house was vacant and a dog or cat had probably ventured inside looking for shelter and died.

On July 9, another neighbor noticed the strong smell of gas emanating from the corner house and called the Gas Light Company. Mr. Henry Haniak was the unlucky employee assigned to visit the house on Division Street.

Since the house was listed as being vacant, Henry decided his best means of entry was to enter via one of the cellar windows; the meter was after all, in the cellar. After carefully removing one of the glass panes, he gained entry to the house. The meter was tagged as being shut off, but it soon became apparent that gas was escaping from somewhere. After turning off the main gas valve, the employee entered the first floor to investigate further. He was quickly able to clear the first floor but had an unexplainable fear about entering the second floor. Acting on this instinct, he went out to the street and enlisted the help of two other men from the neighborhood.

As they inspected the second floor, it was clear that all the gas fixtures were still intact; however, there was one room at the end of the hall that was locked. Henry and the others attempted to pick the lock but were unsuccessful, partially due to the keyhole being crammed with paper.

Positive that the gas leakage was coming from this locked room, Henry was unwilling to leave the premises without further investigation; there was, after all, a real risk of fire or explosion. It was soon decided that the tallest of the men would stand on a small table that was nearby and look through the transom, the piece of glass located above the doorframe.

The man reported seeing what he believed to be a body in the locked room. Fearing the unidentified person might be in danger or even dead, he attempted to push the transom open—a task that proved to be difficult since the crevices had also been stuffed with paper. Undiscouraged, he continued with his quest to gain entry until the opening finally gave way and he could peer inside. Even though he knew there would most likely be a body in the room, he was not prepared for what he saw. Before he had time to take in the entire scene, he jumped off the table and ran outside, followed closely by

the two other men. Once out of the building, he described what he had seen. Henry ran to the nearest telephone and notified police headquarters. Once the police arrived, they immediately opened all the windows in the house to ventilate the gas fumes. Soon one of the officers kicked the bedroom door in. The scene they observed was quite gruesome.

The horribly decomposed body of Vashti Rowland stretched across the full length of the bed. Aside from being barefoot, she was fully clothed. Warren's body, encrusted with dried blood, lay on top of her. His position indicated that he had been sitting on the bed next to his dead wife and fallen backwards on top of her. Both bodies were described as "enveloped in vermin, while the bed and the floor were blanketed by asphyxiated flies."

The bodies, blackened by long-term exposure to gas fumes, were unrecognizable. One police officer noticed Warren's wooden leg and remembered the pleas of a woman claiming her sister was missing and the description of her brother-in-law. It became quite obvious that Warren and Vashti Rowland had just been located.

Coroner LeRoy arrived at the house and began to make immediate assumptions about the crime scene. His initial opinion was that Warren killed his wife by cutting her throat with a straight razor. He came to this conclusion due to the large amount of blood in the room and the fact that an empty razor case had been found discarded near the bed. He further theorized that Warren, after murdering his wife, tore down the fixtures, including the mantel, pipe and jet from the gaslight. This allowed an unimpeded flow of gas into the room. Determined to succeed with his intention of asphyxiation, Warren crammed paper and pieces of cloth into every crevice of the room where he felt gas could escape.

Soon the news of the morbid discovery spread throughout the city. Vast crowds gathered to peer up at the windows of the room where the crime was

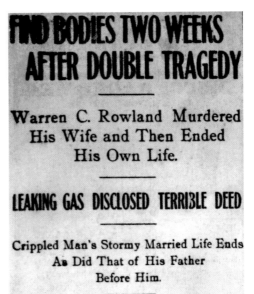

FIND BODIES TWO WEEKS AFTER DOUBLE TRAGEDY

Warren C. Rowland Murdered His Wife and Then Ended His Own Life.

LEAKING GAS DISCLOSED TERRIBLE DEED

Crippled Man's Stormy Married Life Ends As Did That of His Father Before Him.

Headline for July 10, 1909. *Courtesy of* Grand Rapids Press.

committed. The crowds continued to increase in numbers until the bodies were removed and transported to Metcalf's undertaking rooms on Park Street.

While officials were investigating the murder, gossip about the horrific event began among the townsfolk. It seemed to some that the deaths were inevitable. What was up for debate was which of the two was the likely aggressor. Some fully supported Warren Rowland; having known the couple for some time, they knew it was Vashti, not Warren, who drank and was prone to fits of uncontrollable behavior.

The police investigation into Warren Rowland's background shined light on another possible contributing factor to what they believed was a gruesome murder/suicide: genetic mental illness. Just five years prior to the murder of Vashti Rowland, Warren's father had murdered and committed suicide in circumstances very similar to those of the present case. The family, including Warren, had all resided in Oakland, California, at the time. It was believed that Warren moved to Michigan to leave the stigma of his old life behind and escape his macabre family history. What he was unaware of, however, was the mental damage that had already been done.

As quoted in the *Grand Rapids Herald*, "Authorities were inclined to believe that the younger Rowland was the victim of an inherited fatalism or suicide mania, and this led to the terrible tragedy of two weeks ago and its discovery yesterday."

The citizens of Grand Rapids would soon get another surprise from an unexpected source: the autopsy of Vashti Perry-Rowland. It revealed that the woman had not been violently murdered as originally suspected. No wounds were found on her body. Instead, the medical examiner established "that she met her death from asphyxiation while in an unconscious condition due to an excess of liquor." In short, she died from inhalation of gas fumes while passed out drunk.

Coroner LeRoy, who had made the initial observation that Warren had slit his wife's throat with a razor, withdrew his claim as a thorough examination proved Vashti had no wounds on her neck. While the town had already decided in the court of public opinion that Warren had beat his wife with his wooden leg until she died, this too was proven to be false, as her skull had no contusions.

It was later determined that the deaths were a result of a suicide pact. Warren's autopsy proved that the blood encrusted on his clothes and bedding had all come from the self-inflicted wound on his throat. This new evidence confirmed the fact that he turned on the gas first and then used the razor on himself. Whether due to mental or physical fear, he did not succeed in

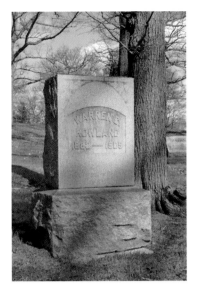

Warren Rowland's final resting place. *Photograph by Nicole Bray, 2010.*

inflicting a fatal wound; however, his back-up plan of asphyxiation worked.

Vashti Rowland's family collected her beloved body the next day and transported her back to Detroit for a Christian burial. Warren Rowland's body went unclaimed for several days. Eventually, Undertaker Metcalf received a note from Warren's sister, who was more than capable of paying for his burial. Instead, she wrote, "No funds; do as you wish with the remains of Warren C. Rowland." It was clear his surviving relatives had little regard for him.

As was customary at the time, Warren was scheduled to be buried in an unmarked pauper's grave at the local poor farm cemetery. No service would be given, no sorrow-filled friends or family would come to mourn the loss beside his grave and no minister would attend to give one last prayer for his soul. In fact, Warren would be buried in complete silence as his body was lowered to its final resting place by farmhands.

The day before he was to be interred, his friends Henry Davis and Harry Hooper informed Metcalf that they would cover the expenses for Warren to receive a proper burial. The body was given a zinc-lined box, and Reverend Lincoln Vercoe gave a last prayer while the body was moved to its new resting spot in Garfield Park Cemetery.

So ends the harrowing history of a crime dubbed by the press in 1909 as "the most fiendish crime in the annals of local police." This may be where the story of the crime ends, but as for the haunting, it was just the beginning.

Despite the ghastly history of this house, the owner of the home rented the rooms out to boarders from time to time. Soon, another tragic event would take place.

According to a December 11, 1923 *Grand Rapids Herald* article, one of the boarders only survived thirteen days in the house. The article does not mention the cause of death; it does, however, speak of what happened to his body following his expiration.

The man's body was brought down to the front room and placed inside a coffin for viewing, as was customary. Just before the funeral services were to begin, a candle that had been recklessly placed too close to a curtain caused an inferno that soon spread throughout the entire room. The fire was eventually extinguished but not before the entire coffin with the body inside was "burned to a crisp."

It seemed no one was interested in purchasing or residing in a home with such an attached stigma. The neighborhood children incessantly claimed that the Judd-White House was haunted, and people near the building at night often testified to seeing strange lights radiating from the abandoned structure. Several reputable people witnessed a macabre vision of a screaming woman. Until the building's demolition, this dejected house remained the stem of many childhood dares and legends.

In 1924, the infamous Judd-White House was torn down and replaced by the structure that stands today. This new edifice would be named the Michigan Bell Building. Now owned by AT&T, the tales of haunting never ceased; it seems the ghosts do not care who owns the property.

One of the most common myths about this infamous ghost story is that the level of paranormal activity on the second floor is so extreme that company officials have closed it off. I received an e-mail from a man named Tom many years ago that disproved this claim. Tom was interested in the paranormal and was inside the building for a training class. During his downtime, he decided to take a trip to the second floor, expecting it to be a restricted area. Instead, he found the entire floor in use like all the rest. Disappointed, he began to ask his co-workers if they had ever witnessed anything out of the ordinary in the building. Several of them reported seeing a female on the upper floor.

While searching the Internet for other people who have had personal experiences in the building, I made a surprising find. While visiting a website known as Michigan's Otherside, http://michigansotherside.com, an undisclosed person shared a story he had heard from his mother. His mom, a former employee, had once witnessed a female apparition dressed in nineteenth-century clothing wandering the fifth floor. Interestingly enough, this makes two reports of the same apparition being seen almost eight years apart.

In 2012, while walking past the Michigan Bell Building, a friend shared a story relayed to him by an uncle who still worked in the building. His uncle had seen a male apparition walking around on the second floor. This male entity has been reported from time to time by other employees as well,

Judd-White House before its razing. *Courtesy of Grand Rapids Public Library Archives.*

albeit not as frequently as that of the female. Perhaps Vashti's soul is more tortured by her sudden death than her husband was by his last desperate acts. There is yet another reason Warren's spirit may be restless and trapped at this site. It appears he was robbed of a large sum of cash after his death. Mr. Rowland was reported to be in possession of a hefty amount of money when they rented the buggy, yet no money was found on his body. Could it have been taken by a police officer or the coroner? No one knows. This claim of lost money is confirmed by Vashti's brother Louis Perry in a July 12 newspaper article, in which he stated, "I cannot understand what happened to the money that Rowland had on the day he is supposed to have killed Vashti. Rowland was in the habit of keeping his money in his wooden leg."

Vashti's younger brother went on to say that Rowland had more than $100 on him the night of the murder. When considering why someone would rob a corpse, you must consider several factors. One is that when the first person arrived on the scene, Warren was looked at as a cold-blooded killer, not a suicidal husband overcome by grief. This would help the thief keep a clear conscience. Another factor is that $100 in 1910 was the equivalent of approximately $2,340 in 2013; this would have been two or three months pay to an individual in the early 1900s. Given these two facts, it does not seem to be out of the question that an otherwise honest man might have been tempted to pad his wallet with the stashed money.

There is one last interesting development in this case. In the past few decades, prank calls have been on the rise in the city of Grand Rapids.

When answered, there was nothing but static or silence. Most people hung up the phone and forgot about it. However, some had received so many repeated crank calls late in the night that they reported them to the police. In several of the cases, they were able to trace the calls back to a second-floor extension of the Michigan Bell Building when the office was closed. Could the ghosts of the Rowlands be reaching out for help? Regardless of why the couple is trapped in this plane of existence, it is clear that this historic building is home to at least two ghosts. Perhaps Warren C. Rowland is still trying to clear his name; maybe this book can help him to do just that.

CHAPTER 3
KENT COUNTY'S FORGOTTEN CITIZENS

Location: multiple locations in lower Michigan

In my many years as an investigator, I have done research in hundreds of cemeteries. By far, the most depressing ones to visit are the poor farm cemeteries, which are commonly referred to as "potter's fields." For many counties, it is hard to find evidence that these graveyards ever even existed due to the constant neglect, as was the case in Kalamazoo and, until recently, Kent County. Forgotten in life; forgotten in death.

Potter's fields emerged when Michigan's government passed the "1805 Act for the Relief of the Poor." The Michigan governor and several judges modeled it after a similar law already implemented in New Jersey. The act made it possible for a pauper who resided in Michigan to ask the state for aid. To have it granted, he had to petition three individual justices of the peace and prove he was destitute of support and incapable of labor. After a brief investigation, if the judges found the claims to be legitimate, the pauper became property of the county and received state aid of "no greater than twenty-five cents per day."

In the year 1809, the state amended the act by integrating laws used to govern the poor in the state of Vermont. Under the revised law, there was no need for the poor to track down three justices of the peace. Instead, a pauper had to petition a tribunal known as the Overseers of the Poor. It was up to the three men in the committee to determine who was eligible for public support. I cannot even begin to imagine how depressing of a job that must have been!

Eight years later, in 1817, it was determined that the "Act for the Relief of the Poor" needed to be amended once more. This time, Michigan adopted practices from its neighboring state of Ohio. The new changes called for the children of destitute families to apprentice in exchange for his or her family's care. This modification required the young to work grueling hours in order to satisfy the requirements of the state. This slave labor is an image that today is often associated with the poor farms of this era.

Over the next decade, many revisions to the law passed. It was not until the year of 1830 that the Legislative Council passed an act requiring every county in Michigan to build and maintain a poor farm. The first to complete its poor farm was Wayne County. Today, the former Wayne County Poor House is best known as the infamous Eloise Asylum for the Insane.

Public Act 148 of 1869 revised and consolidated all previous amendments relating to the support and maintenance of the state's poorest citizens. This new act directed the Board of Supervisors to erect more poor houses and required the education of pauper children between the ages of five and eighteen. It was worded in this new law that the numerous poor houses "will exist to house people who are of poor health, diseased, mentally ill or other problems and have no other means of support."

In 1855, Kent County purchased a parcel of land on the southeast side of Grand Rapids that would become its poor farm. The property consisted of eighty acres located on Thirty-second Street, between Kalamazoo Avenue and Breton Road. The first paupers were moved there on December 1, 1855, and by the year 1896, a total of 238 men, women and children called it home.

In 1909, poor houses received a facelift of sorts when they received a more respectable name: county infirmaries. By this time, every one of Michigan's eighty-three counties had established an infirmary. In 1938, there were still seventy-nine remaining, many of them with self-supporting farms. These working farms gave birth to the now common term "poor farm." Perhaps one of the most telling signs of how these underprivileged folks were viewed is the title used to describe them: inmates.

Healthcare in the infirmaries was meager; the job for physician went to whoever submitted the lowest bid. Many inmates of these institutions, including woman and children, would die of illnesses and injuries that the average Michigan citizen would recover from with proper medical care and medications. Many of these infirmaries were simple injuries from farm accidents, influenza, pneumonia and tuberculosis.

While researching the history of Michigan's infirmaries I came across one county home whose mistreatment really stood out from the others:

the Ingham County poor farm. This establishment used almost barbaric measures to deal with its mentally ill inmates. Historical photos show chains attached to walls and beds. These conditions were the result of the farms being unable to treat the mentally ill effectively. The people who ran them had no instructions on how to care for these special cases. Due to this lack of training and experience, the medical personnel and caretakers would do the only thing they could think of to keep the unstable person safe—chain patients to the wall or bed. Unfortunately, this was often the solution to stop them from hurting themselves and others.

In the 1950s, there was a major decline in the number of active poor houses throughout the state. It was at this time that Kent County officially closed down the poor farm and established the Maple Grove Medical Facility. They designed this facility to cater to patients with chronic illnesses. Today, Luther Village, an assisted living facility, occupies the site.

Occasionally, the design of a poor farm would include its own cemetery on the property. These graveyards, many of which have been lost, are a depressing reminder of how forgotten by society these people of the past have become. Most of the inmates were devoid of any funds of their own to pay for a proper burial. As a result, they received substandard interments provided by the county. Many of the deceased ended up in small mass graves or in private graves with no markers. Only a few people were lucky enough to

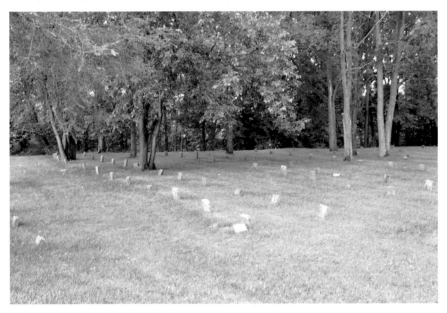

Maple Grove, former poor farm cemetery. *Photograph by Nicole Bray, 2010.*

have family members claim their bodies so they could receive a respectable burial elsewhere.

One of the most macabre finds during my research into poor farms was the lack of burials during the 1920s. While researching this mystery with Ingham County Home Cemetery for the *Paranormal Lansing* book, a local historian informed me that during the 1920s, poor farms throughout the state often received payments from large universities for cadavers. As a result, many of the inmates who died during this period were shipped off to local schools, dissected and then disposed of as medical waste.

The former Kent County poor farm cemetery, which has been renamed Maple Grove Cemetery, is not much different from any other poor farm burial ground I have visited. The main difference is that numbers carved into granite make up a vast majority of stones in this graveyard. There are only a few actual grave markers with names on them. As if that is not somber enough, a trip to the back of the cemetery reveals rows of depressions that are evidence of sunken and unmarked graves.

While looking for an answer, we discovered a 1972 *Grand Rapids Press* article that had an interview with a former employee of the Kent County poor farm in which he talked about witnessing several burials in this section of the cemetery. When discussing the method of interment, he mentioned that there were no caskets used. The bodies were "simply draped in cloth and buried." While one can find only five to ten grave markers in the back

Lines in grass indicate indentations of sunken unmarked graves. *Photograph by Nicole Bray, 2010.*

of the cemetery, it is evident that many more lay there. Their graves are only recognizable due to the deep-set patches of ground that have settled around their remains. Sadly, these paupers were not even fortunate enough to receive a number marking the spot where their weary bones were discarded.

Kent County, like many other counties, used this desolate cemetery for more than just its poor folk. Newspaper articles and obituaries testify that a wide assortment of unfortunate souls rest in this hallowed ground: homeless citizens discovered deceased in boxcars, unidentified bodies that washed up along the Grand and Thornapple Rivers, unclaimed murder victims, unwanted suicides and an occasional prisoner or two.

For a few of the people buried here, the pathetic, unmarked graves would not be their last injustice. On August 22, 1972, construction crews with bulldozers and earthmovers were grading the road in preparation for the construction of the Calvin Christian Retirement Home. The workers inadvertently unearthed five human skeletons. By the following day, fifteen bodies would be uncovered. These burials were located approximately fifty feet from the rear of Maple Grove Medical Facility and buried only forty-five inches beneath the surface. The Kent County Medical Examiner estimated the bodies to be more than one hundred years old and said that some of the remains were those of children.

Captain Thomas Fitzgerald, a local researcher, looked into the history of the Maple Grove property and the land adjacent to it. He discovered that Kent County purchased the area where the unexpected remains lay in 1857. The land had previously been part of the Evans farm. Unfortunately, the deed had been lost in a fire. The found remains were located approximately 350–500 feet from the known surveyed boundary of the poor farm. Could they be members of the Evans family, laid to rest on their own land?

In a *Grand Rapids Press* article that came out shortly after the grisly find, there was a lot of speculation about the source of the original interments. Inspector Lewis VanderMeer from the Grand Rapids City Police Department suggested that an epidemic may have occurred in the area and quick burials became necessary. This would explain why some of the skeletons found were less than two feet under the surface.

We will never know if the remains were that of a family plot sold with the land, misplaced bodies from the poor farm inmates or remnants of a smallpox or influenza epidemic. Regardless of this missing piece of the puzzle, the county decided to take responsibility for the burials. All fifteen bodies were reinterred into the existing poor farm cemetery, where they received a "proper and Christian" burial. Few people attended the impromptu funeral

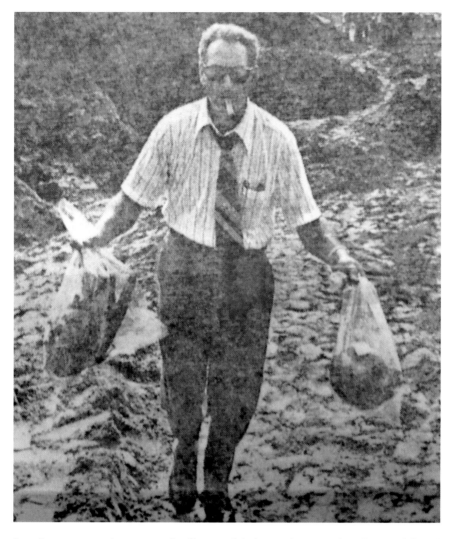

Investigator removes human remains discovered during road construction. *Courtesy of* Grand Rapids Press, *August 23, 1972.*

where all the remains were placed into one steel-reinforced vault; each "person" placed in a plastic bag. Despite the county's Christian burial, no one has yet been willing to purchase a marker for these forgotten souls.

With the history of these poor farms—filled with death, disease and emotional torture—it is little wonder why their cemeteries throughout the United States seem to display a great deal of paranormal activity. If you are hoping to have a true paranormal experience, the best place to start is in a

former county poor farm cemetery. It is difficult not to feel saddened by the lack of recognition of these former citizens. They were people just like us, yet they lay underground as forgotten outcasts.

In 2003, the West Michigan Ghost Hunters Society (WMGHS) was lucky enough to perform our first paranormal investigation of this almost forgotten area. Armed with digital cameras, audio recorders and infrared thermometers, we slowly made our way toward the back of the cemetery. As is protocol, our team split into two groups to ensure that no one was wandering alone. We do this for two reasons; the first is to encourage safety, and the second is that any paranormal event witnessed by more than one person holds more credibility. Each group remained on opposite ends of the cemetery to eliminate the possibility of contaminating any evidence collected.

At one point, our group was near the rear portion of the cemetery when we were assaulted by a horrible smell. The best way to describe it is to imagine what a person would smell like if they had not bathed for a couple of years. It was so overpowering that we had to cover our faces with our hands to staunch the odor. It was an immediate, "hit-you-in-the-face" funk. Within a mere fifteen to twenty seconds, the smell disappeared as quickly as it had come. Thankful for fresh air, we trekked on.

The quietness of that night was soon over. The second group loudly shared that a horrible odor had just surrounded them. Knowing exactly what they were referring to, our group devilishly giggled. Karma soon smacked us back down; once the other team said it dissipated, it immediately reappeared right next to us. On the other side of the cemetery, we could hear Nicole's father, George, laughing. Being the oldest member of the WMGHS family, George was like a parent to the entire group. He could see what was happening and knew, in the interest of equality, we deserved another blast. Thanks, Dad!

Just as it had the first time, the overwhelming smell surrounded us for no longer than a minute. It then vanished and reestablished itself back by the other group. We seemed to be stuck in a very stinky version of tag with an unseen opponent, the disadvantage being that one had to deal with the stench when we were "it." The speed at which the odor bounced from one side of the cemetery to the other made it apparent that something unnatural was playing with us.

The next time this entity moved, we grabbed the audio recorder and prepared for the pending onslaught. Within a minute or two, there it was! Fighting a smell so bad that our eyes were watering, we all got serious and began to ask questions. The stench remained longer than normal, almost as

if it were interested in what we were doing. After we finished this impromptu audio session, we thanked the unseen spirits for letting us visit and stated aloud that we were leaving. Instantaneously, the odor disappeared and did not return during our journey back through the cemetery to our vehicles.

Upon review of the audio session several days later, we discovered a muffled reply to our question, "Is anybody here?" Although the response is unintelligible, it is undeniably a man's deep, gruff voice. All of the men with our team that night were on the opposite side of the cemetery quietly trying to capture their own EVP. This sound clip can be found on the West Michigan Ghost Hunters Society's website (www.wmghs.com), along with a description of what we captured. We sure as heck could smell him that night, and now we were able to hear him as well!

Why would a cemetery be haunted? It is a dismal thought that when we pass on, we are stuck in the area surrounding our final resting place. While I seriously doubt this to be the case, there are entirely too many reports of paranormal activity occurring in cemeteries for one to discount it altogether. It may, in fact, be home to a few restless spirits. Are these forgotten souls still lingering on the now desolate land that once housed them? Could it be that the spirits of unfortunate paupers, forgotten by society, have attached themselves to the graveyards? Maybe they stick around because their bones are the only surviving evidence that they ever even existed.

CHAPTER 4
URBAN LEGENDS

Location: Greater Grand Rapids area

As a child, one of my favorite television shows was called *Fact or Fiction?* In it, strange accounts of the supernatural and the impossible were reenacted in short clips. At the end of the show, viewers were asked to pick out which of the segments were true and which were the products of their writers' imaginations. Sometimes it was obvious, other times it was a shock to see how a story that appeared so real with so many details was actually made up. The same concept applies to urban legends. It's amazing how over and over again we hear of newly circulated stories, and before you know it, they are talked about as hardcore facts.

If you took a moment to look up the meaning of "urban legend," you would find the following definition: "Urban legend—a story that appears mysteriously and spreads spontaneously in various forms and is usually false; contains elements of humor or horror and is popularly believed to be true."

The spooky campfire stories of decades gone by are perfect examples of urban legends. Every town embraces its own macabre tales of strange people, the supernatural or some horrific tragedy. The Grand Rapids area is no different from any other city, except that the number of urban legends is higher than one might find in a sleepy small town.

This chapter is devoted to two of the most infamous urban legends of Kent County: the Ada Witch and Hell's Bridge. Some of you may have already heard these tales; perhaps you have been one of the many storytellers who have continued to spread the "facts." At the end of this chapter, you too will be left wondering, "Was that fact or fiction?"

Hell's Bridge

Located just six miles north of Grand Rapids is the infamous Hell's Bridge in Algoma Township. This bridge first became popular through the antics of a now-disbanded paranormal team composed of employees from the old movie theater known as Studio 28. Since their introduction of the tale of Hell's Bridge into Michigan's pop culture, this legend has grown in leaps and bounds, becoming more dramatic with each ensuing account.

The Hell's Bridge legend started out simple enough. In the mid-1800s, a psychotic serial killer stalked the small village of Laphamville, now Rockford. The murderer preyed only on small children, killing them and throwing their remains into the water. After floating downstream, the little bodies would become entangled on a bridge that crossed the Rogue River, forcing them to wash up onshore.

Apparently, this first version was not satisfying enough, as a more detailed and morbid story was eventually dreamt up. This time the serial killer was given a name, and he became a beastly man known as Elias Friske.

While attempting to find the complete story, I found the following excerpt posted on the Haunt Spot website. This story, used with permission, is a larger and more detailed version of this ghastly legend:

In the mid 1800s, when towns began to emerge in this wooded area of Michigan, children went missing. It left the improvised towns in shambles, all work and expansion stopped. The townsfolk turned to their church to find comfort and answers. In attendance was the enigmatic Elias Friske. He seemed to be a kind older man with a fondness for children. He asked to preach that day.

Elias preached of hellfire and brimstone, and of demons that surrounded the town. He demanded the congregation's prayers or the demons would return and take more children into the dark abyss. With renewed purpose after hearing Elias preach, the town organized a search party to find the children, and to hunt the dark souls that took them. The townsfolk believed that Elias was too old and frail to join the search. They asked him to watch the town's remaining children. Elias agreed and told the search party he would take the children on a picnic, near the Rogue River. Elias explained that if the search party came back with bodies in tow, the children would be away and spared the horror.

Elias tied rope around each child's waist, creating a human chain that Elias led. "We don't want to loose [sic] anymore," Elias jokingly said. The children waved their tiny hands as they watched their parents head off in the opposite direction. Elias began their march into the woods.

The walk to the river was long, and the children soon tired. They asked Elias to take a break, but Elias harshly tugged on the rope leading them further into the woods. The children became frightened and begged Elias to stop, but he continued to drag them along. Soon, the children noticed a strange and horrible odor. Elias deeply inhaled the stench.

Elias pushed the children up against a tree and tethered them to it with the rope he led them with. He shambled over to a pile of leaves and uncovered the source of the smell. It was the missing children, skinned and beginning to rot. The children began to scream and cry, but the search party was miles away, far out of hearing distance.

One by one, Elias destroyed their young lives, forcing the living to watch each cut, to hear each bone break. After Elias finished his murdering rampage, he awoke from his blood lust and realized the impact of what he had done. He could not return to town. He had to escape.

Elias threw the bodies of the children into the Rogue River and he fled further into the woods.

It was dark when the townspeople returned to town. Elias and the children had not returned. It took only moments for the townspeople to realize the ruse devised by Elias Friske. Fearing what darkness may be unleashed onto the children, the search party rushed into the woods that Elias had marched into.

They arrived at the bridge that had recently been built in order to cross the unpredictable Rogue River. There, gathered underneath the bridge in the icy waters, were the mutilated bodies of their children. Among the screams and wails, one young man noticed a pair of muddy footprints leading further into the woods. He sprinted in their direction and he eventually found Elias Friske, stained with blood.

The young man dragged Elias back to the bridge. Elias screamed about how demons had taken control of him and that he deserved pity. The magistrate simply responded, "Hang that son of a bitch."

The rope that Elias had bound the children with was recovered and tied around his neck. The townspeople, without ceremony, hung him off of the bridge. After Elias' body stopped twitching, it's said that the waters underneath him swelled, and snapped the rope that Elias hung from. His body was swept away down river never to be recovered.

The bridge that Elias hung from is now known as "Hell's Bridge."

The first step to investigating this legend was to try to find the story it was based on. My research began.

After spending several days looking up census records that would at least loosely fit the time of the story, I was unable to find the man mentioned in

the legend. I found members of the Friske family, but no one by the name of Elias. After remembering that men often used their middle names instead of their given names, the decision was made to widen the search. Once again, I combed through the census records, and once again, it was discovered that no one matching the name of our alleged child serial killer could be found in them or any of the local land deeds. Maybe the storytellers had the correct last name but possibly an incorrect first name.

Rob and I contacted the Algoma Township Historical Society and were greeted by a very informative and helpful woman named Julie Sjogren who, by coincidence, married into one of the original families that settled the area. Julie, it turned out, is a cousin of the Friske family—many of whom still reside in Algoma Township and are not exactly thrilled to be linked with the old legend.

Julie confirmed what I had already begun to suspect: the elusive Elias Friske never existed, nor had any member of the Friske family committed a murder of any kind. In addition, there is no historical record of mass disappearances or murders of the town's children.

The bridge that is so pivotal to this legend is also in question. The small metal walkway that was made popular by many books and now serves as a Mecca to local paranormal enthusiasts is not the original bridge. If you investigate the base of this walkway, you will discover the cement foundations of a former overpass. Could this be the foundation of the now infamous bridge?

The research leads me to think otherwise. One reason is that the bridge simply was not in the correct location. The small metal walkway crosses a creek that flows into the Rouge River and not the river itself, as stated in the legend. There is also the simple fact that this bridge is barely five feet from the bottom of the creek, making it an unsuitable place for a hanging, even by a lynch mob.

Other people who have put time into researching the history of the area rather than relying on the word of mouth of teenagers think they may have found the actual bridge of legend. This bridge lies north of the metal service walkway and is now a part of the White Pine Trail.

People continue to flock here hoping to catch a glimpse of the serial killer's apparition or the sounds of children begging for their lives. This despite the fact there is no evidence to support the story told in this legend and the fact that no member of the Friske family, past or present, has ever committed a single murder.

Have some visitors to this creek experienced paranormal phenomena? Numerous people claim that they have. Their experiences will be discussed

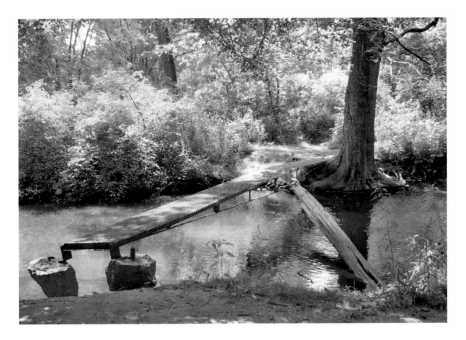

Hell's Bridge. *Photograph by Nicole Bray, 2011.*

in the chapter on Algoma Township. As you will see, even though the legend of Elias Friske is just an urban myth, there is still plenty of supernatural activity in Algoma Township for those willing to look for it.

The "Witch" of Ada

Nearby Ada holds a legend that has withstood the test of time, even with few real facts to prove its actual existence. The Ada Witch is permanent local folklore among the citizens of this small town. Many people have claimed to spot this chilling female entity, but with little concrete evidence of this woman's name, it is hard to identify who this spirit truly is.

This sordid legend begins with a married young woman who was having a secret affair with a local man. They would meet in the woods near her home, which is now part of Siedman Park, for clandestine rendezvous. The young harlot's husband began to grow suspicious of his wife's forays and decided to follow his beloved into the woods. There he came upon his wife meeting with her lover. He stopped and gazed upon them for quite some time before he became enraged and confronted the pair.

It was then, according to legend, that the husband killed his cheating wife. The newly made widower soon turned his attention to his dead wife's lover; however, he was not so easily defeated. A deadly battle ensued, and the men traded possession of the widower's knife, each of them managing to inflict fatal wounds. Both men were said to have succumbed to their wounds and died in the woods next to their mutual lover.

Historians, news journalists and paranormal investigators alike have been looking for historical evidence that this legend is true. To date, no one has been able to come up with any valid facts. In addition, there is no evidence that even if the story were true that there was any witchcraft going on. This makes labeling the young woman a witch a little extreme; it does, however, make for a better ghost story!

In 2003, a rag-tag group of paranormal enthusiasts insisted they had discovered the identity of the Ada Witch, whose name was Sarah McMillian. This new piece of information spread like wildfire across the Internet and within the teenage community. Visitors, benign and malevolent, began to visit Findlay Cemetery to see the "witch's" grave.

Unfortunately, the malevolent visitors overtook the cemetery, and their destruction became more prominent. Sarah's stone is almost completely demolished. Vandals, all with their own motives, started to break the stone into small pieces. What motives would bring someone to destroy a woman's grave? For some it was done for their own amusement, for others it might have been for a hint of teenage notoriety and for a few, it was done for financial gain. One local was so desperate for money that he was selling pieces of the tombstone on eBay. The listing read, "You too can have a piece of the Witch!" The auction was for a piece of her tombstone and dirt from her grave. No matter the motive, the marker that once sat on Sarah's grave is almost completely gone.

The benign visitors were satisfied with simply taking pictures and being able to boast to friends that they had stood by this cursed woman's grave. I say cursed because that is what her name and place of rest have become, a curse to Ada Township and Findlay Cemetery.

Several years later, a journalist was able to clear the name of Sarah McMillian. She was not the woman who was the catalyst of the Ada Witch legend. Sarah, in death, was the victim of someone else's search for notoriety. In life, she was a simple young woman who, at the age of twenty-nine, tragically died from typhoid.

Knowing that Sarah was unlikely to be the legendary witch, Rob and I decided to see if we could find a likely candidate. We also wanted to verify

the cause of death of the poor woman. What we found was a surprising part of tragic history in the small town of Ada.

First, we looked into the woman of legend, Sarah McMillian. Hours were spent at the Kent County Clerks Office pouring over seventeen huge books that contain every death in Kent County from 1867 to 1960. We discovered that Sarah McMillian did not die in Ada Township. We know this because there was no record of her death, only of her burial. This means she died elsewhere and was returned home to be buried with her family in Ada Township. We were also able to verify that her husband, Archibald, who died in 1932, is not buried with her. These two facts eliminate Sarah as a possible match for the Ada Witch.

The next mission was to find a trio that might match the legend. To accomplish this, we looked for any time three people died within days of each other. We further limited our search to a trio where the cause of death for each of them was listed as accidental death, unknown death or homicide. The only time any deaths came close to matching the legend was when a fifty-four-year-old farmer named John Ernhardt died of an accidental death on August 3, 1877, and seventy-year-old Lawrence Doyle died of accidental death seven days later. These two men were not the right age to match the legend. Furthermore, there was no death of a female from unnatural causes in that year.

The research did open our eyes to a heart-wrenching local tragedy. In 1880, Ada Township experienced a horrible diphtheria outbreak, which took the lives of many children in the area. We can only imagine the pain that was felt by the countless parents, especially one ill-fated family who lost six children in just four months. It was a very somber experience.

Despite the fact that no one has yet been able to prove even one of the elements of the Ada Witch legend, it continues to spread as fact. In addition, Findlay Cemetery and the surrounding area continue to be the subject of many reports of paranormal activity. Unexplained blue and green balls of light have been spotted in cemetery after dark for over a decade. There are a myriad of accounts of a female apparition in a long dress walking down the area dirt roads.

It is hard not to sit and wonder which is more tragic: the fact that Sarah McMillian perished from a dreaded disease or that due to people's lack of respect, her eternal resting place has been cruelly desecrated repeatedly over the years.

Is this cemetery haunted? There are too many reports of paranormal activity not to at least consider the fact. There is, however, no evidence to suggest that the legendary witch is behind it or that there ever was such a witch for that matter.

CHAPTER 5

PHILLIPS MANSION

Location: Prospect Avenue in Grand Rapids

I f you live in Grand Rapids and are into ghosts, you've most likely heard about one widely publicized haunting, the Phillips Mansion located in Heritage Hill. It has been featured in several news articles, magazines and Gary Eberle's *Haunted Houses of Grand Rapids* book. People who have lived there have witnessed the ghost of James T. Phillips. He was the owner of the Grand Rapids Clock & Mantel Company who lived in the stately home for over thirty years.

Like the legend of the Ada Witch, I did not want to simply retell the same story that has been told a hundred times before. Once I started on the historical research, however, I realized I didn't have to. I discovered that the mansion has even more of a gloomy history than people know about.

In 1864, William B. Renwick built his family a Greek revival farmhouse on Prospect Avenue Northeast. It was sold to Robert Loomis in 1870. Loomis was a deacon and founding father of the Fountain Street Baptist Church. He took out a mortgage of $2,500 and transformed the farmhouse into a gorgeous piece of Classic revival architecture. He added the rear carriage house and, most important, the large pillars located in front of the home.

In 1880, the mansion again changed hands when it was sold to James T. Phillips. The family consisted of James's wife, Julia, and their four children: Francis, Abbie, Bright and Mabel. Together, they spent thirteen happy and

productive years inside this dwelling. As time went on though, sadness and death seemed to fill the home.

It began with their daughter Abbie who, at the age of twenty-one, passed away on March 9, 1893 from an unknown cause. Her obituary stated that she had died in the home and that her funeral was to take place at the residence, as was common in those days. She was laid to rest in Valley City Cemetery, which is now the southern portion of Oakhill Cemetery.

Although feeling an insurmountable amount of grief, the Phillips family carried on. They remained in the home and continued with their lives. Their daughter Mabel soon married William Wallin, and together they welcomed a beautiful baby girl into the home in 1909. They named her Julia Phillips Wallin, in honor of her grandmother.

On the evening of March 12, 1912, just three days past the nineteenth anniversary of Abbie's passing, James returned home from his clock factory and went upstairs. Minutes later, the servants heard sounds of distress coming from his bedroom. They ran upstairs to find James in the throes of a heart attack, from which he died a few minutes later; he was sixty-seven years old. His death came as quite a shock to his family and friends. Like Abbie before him, his funeral was held at home, and he was buried at the Valley City Cemetery, one plot away from his beloved daughter.

Soon after James passed, his wife, Julia, decided to sell the mansion to William and Mabel. They were elated and insisted that Julia remain in the home with them. One year later, the specter of death showed up on their doorstep again. Four-year-old Julia Phillips Wallin passed away from intussusception, a medical condition where the intestine folds into itself, much like a collapsible telescope. She was buried with her grandfather and Aunt Abbie. The following years were spent grieving the loss of the young girl.

Mabel and William conceived a second child in 1915. Sadly, in August of that year, Mabel delivered a stillborn baby girl in the home on Prospect. The child is buried next to little Julia. In 1917, the matriarch of the family succumbed to a manner of death similar to her husband's, an inflammation of the heart. Julia's services were held in the family home and she was interred next to her faithful husband, James, for eternity.

The Wallins decided to sell the Phillips Mansion after the death of Mabel's mother, a decision that must have been bittersweet. How sad to leave the home in which she grew up, yet what a relief to leave behind all the tragic memories and start anew. Unfortunately, the heartbreak of losing her children proved to be too much for Mable to bear; she passed away four short years after moving from the house.

Front row: Abbie, Julia and James. *Back row:* little Julia and the infant. *Photograph by Nicole Bray, 2010.*

Dr. Fred Erastus Burleson purchased the Prospect Mansion from the Wallins and moved his family into the house. They also experienced their share of tragedy. Mary Maxine Burleson, the doctor's daughter-in-law, died in one of the bedrooms from "complications due to a toxic thyroid goiter" in April 1927. Despite living with a well-known physician, Mary and her parents were Christian Scientists; they did not believe in medicine but only in the power of prayer. Just prior to Mary's passing, her mother locked herself in her daughter's room and would not allow any doctors or even Mary's husband to enter. When Mary died, she left behind a three-month-old daughter. Mary's husband, Edward, a politician, married again a year later.

In 1934, a fire broke out in the stately home. Luckily, it was spotted by a neighbor, who was able to warn the Burleson family in time for them to make it out safely. The entire roof was destroyed, and a majority of the interior walls and fine home furnishings sustained water damage. The Burleson family was forced to move from their home.

It was during the Burlesons' ownership that the home gained a reputation of being haunted. I received a newspaper article from the 1930s that spoke of a woman named Marian Carpenter, a local spiritualist in an eclectic society known as Spooksville. The group, a tent community located in Briggs Park, would perform readings and entertain people with ghost stories. The submitter of these articles claimed Marian Carpenter was a member of the Burleson family and was known to hold séances inside the former Phillips' home. Was it this article that led people to believe the mansion was haunted?

I was able to locate Sue Bell, a Burleson descendant, to learn more about the family and the mystery surrounding the elusive spiritualist. Sue was able to answer many of my questions. She informed me that Marian Carpenter was never a member of the Burleson family, nor was she a servant who lived in the home. I found a census record from 1930 listing her home address as 446 Benson Street Northeast.

When asked about the Burleson daughters, Sue shared that Dorothy Burleson was a devout Christian. While some members of society, on the other hand, deemed her sister Elizabeth to be wild, she certainly was never an occultist. With no true connection to the occult, the gossipy story of a Burleson spiritualist will have to remain as such, just a figment of local gossip with very little if any truth to substantiate the claim.

After the fire, the home stood unoccupied for two years until restoration was complete. The next owner was Dr. Horace J. Beel from England. A magazine article published in 2009 mentioned that during his ownership, the mansion was used as a nursing home for elderly women. Census records for the residence, however, showed that Dr. Beel lived in the home with four to five servants, none of which were elderly. This was most likely an innocent mistake on the part of the author. In 1912, the city of Grand Rapids changed many street names and house numbers. The original address for the mansion was 126 North Prospect Avenue Northeast. When the change occurred in 1912, the house was given the new address of 152 North Prospect Avenue. I looked at the city directories for further information and found that the original 152 North Prospect Avenue housed a full-time nurse and five elderly female residents. If the author hadn't known about the citywide changes with the addresses, it would have been easy to assume that the Phillips Mansion had been utilized as a nursing home.

In 1946, the Grand Rapids City Directories show that three people resided in the home, two men and one woman. None of the tenants were related, so it would be a fair guess that upon restoration from the fire, the home was turned into a boardinghouse.

In 1972, Merry Schwander and her roommate rented the two-bedroom second-floor apartment in the former Phillips Mansion. Despite some frightening occurrences, Merry and her roommate remained in the apartment for over a year.

One night, while awakened from a deep slumber, she rolled onto her back and was startled to witness the head of a young blonde man smiling at her. Merry knew immediately that this was not a nighttime intruder. The warm smiling face of the young man continued to move across the ceiling before

disappearing entirely. On another night, she was awakened once again by a bright and blinding light emanating from an unknown source. Terrified, Merry jumped out of bed and ran into the other bedroom to fetch her roommate. When they both returned to the previous bedroom, the light had mysteriously vanished.

Despite the occasional disturbances while she was trying to sleep, Merry was determined not to move from the home until another more frightening incident occurred in 1973. In the early morning hours, Merry awoke to the feeling of a strong presence near her. She turned her head to the side and was assaulted by the sight of a frail-looking woman lying on the bed next to her. Merry described the woman as being incredibly thin, as if she had been sick for an extended period of time. This apparition appeared as solid as a real person but deathly white in color. This ghostly specter was breathing noisily and was in obvious pain. Running into the other bedroom screaming, she grabbed her roommate, and they both returned to find the ghastly phantom gone, with nothing but an indent left on the pillow.

Many have speculated that this spirit was a former resident of the alleged nursing home. Now that I know that's not true, I wondered if it could have been Mary, Dr. Burleson's daughter-in-law. The cause of Mary's death—toxic thyroid, also known as "goiter" or "enlarged thyroid"—can cause, among other things, extreme weight loss, heart palpitations, respiratory complications and malignant tumors.

Regardless of the sickly woman's identity, this experience was the last straw for Merry. She began to pack her things that very night. Once she and her roommate were away from the house, she began publicly talking about her experiences to anyone who would listen to her. The home continued on as rental units until 1975.

Because of the publicity generated by the tales of paranormal activity from Merry Schwander, the mansion was sold to two men who were not bothered by the thought of living in a haunted house. Charles "Chuck" Schmoenknecht purchased the home and added Paul Ward as a joint owner. They were caring individuals who painstakingly restored the mansion to its former beauty.

Shortly after moving in, Chuck was sleeping in one of the upstairs bedrooms when he was awakened by the sound of footsteps on the staircase. He sat quietly and listened as the footsteps worked their way up to the second floor and stopped outside his door. Assuming it was an intruder, Chuck grabbed anything he could find for protection—in this case, a shoe—and swung the door open. He was surprised to find no one there.

While the mansion was in its restoration phase, the number of ghostly disturbances increased. Unexplained vibrations would shake pictures off the walls, and strange thumping noises soon became the norm. It was during this time period that the two gentlemen also began noticing items disappearing or being moved all together. At times, these objects were large pieces of furniture.

Guests who stayed at the home during the restoration weren't as capable of ignoring the supernatural events that took place. Several overnight visitors would complain the next morning of being kept awake by heavy footsteps, banging on the walls and the sound of furniture being dragged across the attic floor.

While throwing a dinner party one evening, a sound that was described as a "shattering explosion" was heard from the second floor. Everyone scurried up the stairs to see what had happened, but nothing was found amiss. As they stood in the hallway, they were terrified to see a misty apparition wandering up the staircase, only to disappear when it reached the second floor.

On a different night, the furnace failed. To keep warm, the two men pulled out their sleeping bags and all of their blankets and did their best to get comfortable on the living room floor. But a restful night was not meant to be; they were kept awake by the eerie sounds of footsteps from an unseen tenant walking through the room.

Three years after moving in, Chuck and Ward finally met the most famous apparition in their home. They had been sitting in their living room when an older man suddenly appeared by the fireplace. The two men described this visitor as a "friendly-looking gentleman, with a gracious demeanor." They described their ghostly visitor as well dressed in an Edwardian style, wearing a brown tweed suit. This apparition vanished when Ward walked up to him. They were able to identify him as James T. Phillips by looking through old photographs.

A few evenings later, Ward saw the specter again. He had walked out of his bedroom and was about to descend the stairs when he glanced down toward the entry hall. Standing at the bottom of the steps was the same gentleman wearing the tweed coat. This time, the visitor was also carrying a cane and wearing a bowler hat. While Ward stood transfixed, this friendly entity looked directly at Ward, tipped his hat, smiled and then proceeded to exit the house literally "through" the front door!

Neither of the men was disturbed by Mr. Phillips's ghostly wanderings. In fact, before they identified him, they referred to him as the "nice old guy." Not everyone seemed to be a fan of the paranormal mischief, however. To

help save on expenses, the two men rented out one of the spare bedrooms upstairs. Rick, a friend and art student, not only used this room to sleep but also used it as a makeshift art studio. For whatever the reason, one of the unseen entities was not fond of this new development.

One night after Rick had settled into bed, he was startled when something slammed his door shut. He reached over and turned on the nightstand light to find the door open by more than three inches. There was no scientific explanation for this, as he knew no draft could have slammed the door and then turned the knob to open it back up.

Slamming doors and loud thumping noises seemed to increase during Rick's stay in the home. The sounds from the attic became an everyday spectacle; one that Rick was getting weary of. On one day in particular, Rick lost his patience and screamed at the ghost to "shut up!" A second later, a red cup of paint he had been using sailed across the room. While cleaning up the paint, his canvas crashed to the floor. Apparently, the presence was not appreciative of Rick's rude behavior.

One of Rick's last experiences in the house happened on a hot, steamy night. He lay on his bed reading with his three Siamese cats resting down by his feet. Out of nowhere, Rick was surrounded by a cold draft. All three of the cats woke up at the same time and simultaneously watched the same spot on the ceiling. Rick watched in fascination as all three cats turned their heads in unison, watching some invisible denizen moving back and forth.

Chuck and Ward eventually put the restored home on the market. Julie Rathsack was able to tour the home while it was up for sale on June 26, 1994, and said, "Except for the plush carpeting going up the stairs, it felt like I had stepped back in time. The woodwork was amazing! The light fixtures were all original. It was the perfect specimen of a Heritage Hill home." While standing around in the kitchen, she casually asked the realtor if the house was reputably haunted. The realtor glanced at her for a second like she was crazy but then said with all seriousness, "I have not heard anything that would lead me to believe there is any issue with ghosts." Julie didn't have the heart to tell her what she knew. She did not witness anything paranormal, except for the feeling of being observed by something unseen as she moved throughout the entire home. The attic, nothing but beams and insulation, also gave off an eerie feeling despite being brightly lit.

It is hard to imagine how much emotional turmoil must have taken place within the walls of this home. Today, the Phillips Mansion continues to be a privately owned residence. Perhaps someday, the new owners will add some more experiences to the paranormal list.

CHAPTER 6
SPOOKIEST NEIGHBORHOOD IN GRAND RAPIDS

Location: Heritage Hill Historic District

Next to downtown Grand Rapids is the oldest residential district in the city. The neighborhood, known as Heritage Hill, is made up of over 1,300 houses that date back to 1843. These magnificent homes stand as reminders of all the people who lived in the city before us, citizens who helped shape Grand Rapids into the town that we love today. The homes highlight more than sixty different types of architectural styles that were popular in the nineteenth and early twentieth centuries. As I walked down the street, I began to notice little details like the cast-iron hitching posts and brass doorknockers. They made me feel like I was walking in the past. The sheer beauty and originality of the homes astounded me.

While the area is a treasure trove of timeless architectural treasures, it also houses its own dark secrets. A large number of these dwellings are rumored to be haunted. Many believe the former residents put so much time and energy into building their beloved homes that they chose to stay in them even after death. Historians have also speculated that the district was inadvertently built on sacred Indian land. I believe that these homes have silently witnessed many lives and memories, both good and bad. The events had to have an impact on the energy left behind in the environment, and more energy means more ghostly occurrences. The following true story of a knife-wielding lunatic has certainly created the perfect storm for paranormal activity.

THE MURDERS

In 1970, Shelley Speet Mills was a vivacious nineteen-year-old newlywed who had just moved into a new apartment with her husband. Excited to start their life together, they had taken a downstairs unit located at 314 College Avenue Northeast. Having graduated from high school just the year before in 1969, Shelley already had plans to transfer from Ferris State College to Grand Rapids Junior College. Although the apartment was in a rough neighborhood on the outskirts of the Heritage Hill district, it was conveniently located within walking distance to where Shelley would attend classes.

On the morning of September 15, 1970, her mother, Vesta Speet, drove Shelley's blind grandfather in from Holland to spend the day with her. They visited often and had grown accustomed to Shelley greeting them outside with open arms. That day, however, Shelley was nowhere to be found. The visitors attempted to get Shelley's attention by honking the horn but received no response. Vesta then let herself into the home; what she found was every parent's worst nightmare.

Shelley lay on the kitchen floor. She had been stabbed more than twenty times throughout the area of her neck and head. It was later estimated that she had been murdered only thirty-five minutes after her husband, William, a band teacher at Lowell High School, left for work that morning.

Shelley was a cautious woman and was known to lock her doors; there were no signs of forced entry. It was apparent a struggle had taken place in the kitchen. The murder weapon, obviously a knife, was never found. Shelley Speet Mills, a bride of only three weeks, was laid to rest in her hometown city of Holland.

Approximately one year later, another woman was found murdered thirty-four miles north of Grand Rapids in Howard City. The victim, Barbara Larson, was a twenty-five-year-old woman who had been a student at the Grand Rapids School of Bible and Music located in Heritage Hill. She was found dead in her mobile home. Barbara and Shelley's murders seemed to have striking similarities; both had been stabbed in the head and face, both bodies were left in the same condition and both victims had ties to Heritage Hill. The police became concerned that a serial killer may be on the loose.

On May 28, 1975, the body of twenty-year-old Laurel Jean Ellis was found by her boyfriend Carl Novak. Carl had grown concerned when he had not heard from Laurel in nearly a week. Worried, he went to her

apartment at 627 Fountain Street Northeast around 7:45 p.m. and found her nude and badly decomposed body inside. The autopsy would show that she had been stabbed over sixty times; forty-five of those wounds were to her face, and following that assault, she had been strangled to death. The police found apparent signs of struggle inside the apartment, but no signs of forced entry. A single blood drop was collected from the floor outside of Ellis's door. Unfortunately, at this time, DNA testing was still not available. The local media began to speculate that a serial killer was stalking the women of Heritage Hill.

While the local detectives worked endlessly to solve these three murders, the carnage continued. In less than six months, a fourth victim, twenty-four-year-old social worker Linda King, was discovered lifeless in her home on Clancy Avenue Northeast. Her corpse was discovered by concerned co-workers after she had failed to show up for her job. Her autopsy revealed that she had been stabbed multiple times in the chest and then strangled by her own clothing.

One thing noted by the police was that the murders of Ellis, Mills, Larson and King all had the same modus operandi or "method of operation" (MO). The killer would stab them repeatedly in the upper body and then strangle them with an article of their own clothing.

Fear began to permeate every corner of Heritage Hill, especially in the houses and apartments where college students and other young females resided. Frantic parents tried desperately to convince their daughters to move away from the historical district or return home. While some agreed, most did not. The fear would soon reach an almost unimaginable level.

On March 20, 1976, two friends went to seventeen-year-old Kathryn Darling's apartment at 637 Michigan Street Northeast to check on her. Kathryn was two months pregnant, and her friends had become anxious when calls to her home went unanswered. They knew her husband was serving a five-year prison sentence and that she did not travel or leave home unexpectedly. They found her corpse, bruised and bloodied, in the bedroom. Kathryn's fourteen-month-old son, Michael, was found unharmed in the apartment. Her slaying had the same signature as the other women, except that she had also been beaten. Neighbors began to fear that the murderer's methodology was growing even more violent.

Almost two months to the day of Kathryn's murder, the killer struck again. This time, the victim had been dumped in an open field in the city of Walker, north of Grand Rapids. The remains of Lois DeRitter once again showed the same pattern. Though Lois did not live in the Heritage Hill

district, she had last been seen leaving the junior college located in the center of this historical area.

Seven months later, twenty-year-old Nancy Sweetman walked to her boyfriend's house after Christmas Eve services at Central Reformed Church. Despite the cold temperatures, she declined an offer for a ride when one of the parishioners spotted her near the intersection of Cherry Street and Eastern Avenue Southeast. Neighbors in the 800 block of Neland Avenue heard screams at approximately 12:55 a.m. One neighbor who heard the scuffle looked outside her window and saw a body in the snow. Her call to the police would prove to be an unforgettable shock for one local police officer.

Officer Ronald Sweetman responded to the call and had the heart-wrenching experience of finding his sister's corpse. In a quote from the *Grand Rapids Press* on December 26, 1976, the second officer testified that Ronald exclaimed, "Oh my God. It's my sister Nancy!"

Nancy Sweetman was stabbed multiple times in the neck and chest. After the body was removed from the front lawn of 844 Neland, police would discover blood on the ground in a trail leading away from the body. They also discovered blood on the water spigot of the house next door. It was apparent that the killer tried to wash away any evidence.

On November 28, 1977, Ms. Ida Mae Luchie was discovered in the laundry room of her apartment house at 440 Crescent Street Northeast. She had been dead for several days before she was discovered. An autopsy would reveal that Ida Mae died from multiple stab wounds and a fractured skull from blows to the head by what was determined to be a stairway spindle.

Two and a half years passed before the killer struck again. This time, the victim defied all medical odds and survived her brutal attack, an assault that would prove to be the notorious killer's downfall.

Joanne Eggleston, twenty-one years old, had just returned home from a softball game. Feeling exhausted, she decided to take a nap on her couch. While she slept peacefully in her living room, an intruder broke into her home through a bedroom window. Joanne was startled awake when a man stuffed a macramé belt into her mouth. She heroically fought off her attacker. Enraged by his victim's resistance, the man plunged a knife into her throat with such force that the blade broke off from the handle. Having punctured an artery and her spinal column, Joanne's assailant stood and watched her until he thought she was close to death.

After the intruder vacated the premises, Joanne, who had been paralyzed in all but one arm, managed to drag herself across the floor to

the telephone. When she finally reached it, she grabbed the cord with her teeth and dialed "0" for the operator. Paramedics were immediately sent to her home, and the brave woman was rushed to Butterworth Hospital. She was not expected to survive.

In the emergency room, doctors were physically unable to remove the knife. They were forced to use an unorthodox method. They summoned the hospital janitor to bring pliers. While standing over the woman, a doctor was finally able to pry the blade from Joanne's spine while four others held her down so he could gain leverage.

On July 13, 1980, three days after the attack, the *Grand Rapids Press* featured an article on how Joanne had survived the vicious ordeal. As if emasculated by the article, the power-driven killer felt the need to strike again that very night.

Twenty-year-old Catherine Fingleton was not in bed when her fiancé, David, returned home from work. It was out of character for her to leave without some kind of note. Worried, David phoned Catherine's parents, who both rushed to their daughter's home at 641 Lafayette Avenue Northeast. They soon discovered that all of Catherine's shoes were still present in the home. This only added to their fear, as it proved she had not simply left on an errand or gone out for a walk. They immediately called the police and reported Catherine missing.

When daylight broke, a neighborhood boy found a partially nude body, lying in knee-high grass near the highway overpass at Lafayette Avenue and Interstate 196. The body was that of Catherine Fingleton. An autopsy revealed that she had died by strangulation. The estimated time of death was just minutes before her fiancé discovered her missing. Her body was found only two blocks away from the couple's home.

Ten attractive young women all murdered within a ten-year time span. Were they all the product of a single lunatic? The prosecutors and detectives thought so. Lamont Marshall, a young man in his twenties, came under scrutiny when he always seemed to turn up near the crime scenes, despite their various locations around town. He came across as deceitful and manipulative and seemed to change residences regularly. The detectives were certain he was involved in several of the murders. At one point, Marshall even went so far as to threaten to harm the police officers if they did not back off. One article about the numerous unsolved murders, printed after the discovery of Ida Mae Luchie, quotes Detective John Robinson as saying, "Some of these homicides are solved in our minds. We just don't have enough evidence to get a warrant."

In 1983, Lamont Marshall was called to be a witness in front of a grand jury. While there, he testified that he had never seen the banister spindle that was used to bludgeon Ida Mae Luchie. Detectives, however, were able to prove that the banister spindle had come from a stairway in his home. Having lied to the court, he was indicted and imprisoned. Although it was not for murder, the police were still pleased that he was finally off the streets.

As Marshall neared eligibility for parole, prosecutors charged him with attempted murder in the 1980 attack of Joanne Eggleston. It turned out that Eggleston was able to identify Marshall as her attacker just months before the statute of limitations ran out. He was once again convicted, and this time he received a life sentence.

Prosecutors still wanted to prove that he was tied to the murders that took place in Heritage Hill. In the end, their patience paid off. In 2008, the Michigan State Police crime lab was finally able to analyze the single drop of blood that had been found at the home of Laurel Jean Ellis in 1975. The droplet, which had sat for decades in an evidence locker, matched Lamont Marshall's DNA. He received the mandatory term of life in prison without parole.

Prosecutors and detectives alike have no doubt that Marshall committed some of the other unsolved murders that occurred in Heritage Hill. Unfortunately, there is not enough evidence to back them up in court. We do know that he did not commit all ten of the murders. In January 2011, fifty-nine-year-old Russell Vane was convicted of slaying Kathryn Darling. With DNA to prove his guilt, the court sentenced him to serve life without the possibility of parole.

The Hauntings

Gary Eberle's *Haunted Houses of Grand Rapids* is a fascinating book that holds a barrage of stories about the many local haunted homes in our town. If you live in Grand Rapids and are interested in the paranormal, this book is a "must have."

One story covered in the book is the tragic history of the Lawrence T. Davidson House and of the modern-day haunting the past events created. Built in 1907, Lawrence and his wife, Constance Davidson, lived happily in their home with their two children, Albert and Margaret, for ten years. It was during the eleventh year that the family began to fall victim to a series of tragedies—misfortunes that would, in fact, rip the family apart and eventually lead to the house being left abandoned.

The family's peaceful existence was rocked when their youngest child, Margaret, suddenly fell ill. It was soon discovered that she had a debilitating heart condition from which she never recovered. Margaret died when she was only ten years old.

Her parents were so distraught that they fell into a depression and failed to take care of their own health. They were desperately in need of help. Realizing their need to be strong for Albert, they admitted themselves into a medical care facility where they could pull themselves together both mentally and physically. Their stay was to be cut short, however, when they received another devastating blow. They were told that Albert was involved in a horrific car accident. Though the injuries were serious, the doctors expected him to make a full recovery. His parents left the medical facility immediately to be with their son. Unfortunately, it was not meant to be. Albert Davidson unexpectedly died before his parents could reach his bedside. Albert died on the one-year anniversary of young Margaret's passing. As was common during the times, the devastated couple held a funeral for their final child in the living room of their home.

Lawrence and Constance remained in the house for only one more year. It was never sold, remaining vacant. Unable to recover from the loss of their children, their health took a turn for the worst. Under incredible strain, Constance died suddenly in October 1930. Having lost his entire family, Lawrence succumbed to a heart attack and died only three weeks later. The house was sold in late 1930 and has had many owners over the years.

Rick and Linda purchased the home in the early 1970s. After they moved in, they noticed a mysterious lump on a portion of the wall in their hallway. Curious, they pulled the wallpaper and drywall down to discover a full-sized door that led up to the third floor. Excited, they ventured into the previously unexplored area to see what hidden treasures they could find. They were disappointed when they found nothing but an old, dusty attic. What they did not know at the time is they had just opened a portal to a supernatural realm.

The first hint of anything unusual came when items began to move from one location to another. Things like car keys would be put in the proper place, only to reappear in a strange location minutes, or even days, later. When the paranormal activity heightened to what we would almost call "poltergeist" levels, the couple began to sleep with the lights on. As quoted in the *Haunted Houses of Grand Rapids* book, "The house had taken on an air of its own," Rick states. "It was if the house was alive, and we were the intruders."

Rick was the first person to glimpse an apparition. Standing in the kitchen, he closed the freezer and was astounded to see a vaporous figure of a man standing in front of the cellar door. After several seconds of staring at the specter, Rick ran into the living room. He then told his wife what he had seen.

Linda had her own experience less than two weeks later. While staring out the living room window during broad daylight, she suddenly saw a grayish smoky form materialize on the sidewalk and walk toward the home. Frozen in fear, she sat in her chair and watched as this human form stopped directly in front of the window. It stared in at Linda for several seconds before dissipating. Soon after this unsettling incident, the couple decided to move out of the house.

Another story from the book tells us about the spirit of a proper lady who resides in a historical home on Prospect Avenue Northeast. Built in the early 1900s, this elegant brick home was known as the social center for some of the city's most influential families. The former owner was known to keep the residence in pristine Victorian condition and would conduct herself with perfect etiquette. She insisted on wearing a formal gown to dinner every night. Even after her husband passed away, she would never be seen in anything less than formal attire. She lived strictly in her perfect home well into her mid-eighties.

As soon as the Andersons bought the house, they began to notice strange things. It began with the sound of footsteps on the stairway and on the top floor. Soon the noises were joined by the unsettling feeling of being touched. The eerie occurrences became more frequent and more disturbing. Touching and pinching started to become commonplace within the home.

In a search for answers, the couple contacted a woman who had worked in the home as a maid for many years. She stated that after her previous employer passed away, she was left with the task of getting the house ready to be put up for sale. While cleaning and sorting, she experienced her sleeves being tugged on and minor slaps on her body.

Once, while Mrs. Anderson was working downstairs, she could hear the distinct sound of the piano playing in the living room. Knowing that she was alone in the house, she was convinced that the entity in her home was entertaining her. Classical tunes, such as Beethoven, seemed to be the preferred choice of music for this talented spirit. This proper being from beyond continues to make her presence known, particularly on the anniversary of her death.

A haunting on Madison Avenue is also mentioned in Eberle's *Haunted Houses of Grand Rapids* book. Instead of being a proper Victorian spirit, this one was a mischievous poltergeist.

In 1908, Albert Hicks built an impressive home in the middle of a beautiful neighborhood. When he passed away in the mid-1940s, his wife was moved into a nursing home and the house was sold. Since then, ownership changed hands numerous times.

I did a little research and found that former Michigan governor Kim Sigler would stop at this house several times in the late 1940s to visit friends. What made his visit memorable is that Sigler, nicknamed "Hollywood Kim," would arrive in a limousine with a full police escort.

Like many other private residences in the Heritage Hill district, the home was purchased and converted into apartments. In 1971, a man named John moved into a unit located on the second floor. His first two years in the apartment were relatively uneventful. The last two years, however, were anything but.

Ironically, John's first supernatural experience occurred on Halloween in 1973. Standing in a bedroom, he noticed a strange bulge in the curtain that slowly moved down toward the floor. There was no sound, and the window was closed. When John pulled the curtain away from the wall, there was nothing there. Countless other incidents began to occur. He would hear the sound of footsteps coming from the vacant third floor unit. The door to his spare bedroom would open and close for no apparent reason. Even when he had company, they could hear the sounds of an unearthly being moving about in the spare bedroom. John was beginning to realize he was no longer alone in his home.

On one occasion, John returned home to hear a loud male voice from within his flat. Shocked, he cautiously walked room to room expecting to find an intruder, but no one was found. One night while John was awake in bed, he heard the sound of his doorknob being turned. When he looked at the door, he could see it moving in one direction and then in the other. Having grown numb to the strange happenings in his apartment, he was more fascinated than disturbed by the prank. Soon after, three misty shapes materialized in front of the door. They remained there for a few moments before fading away. The rest of his night was uneventful. In 1975, John decided to move into a more convenient apartment. He packed up his belongings and left his domicile on Madison Avenue with a lifetime's worth of supernatural memories.

Recently, a woman by the name of Jessica stated on a local blog that she and her husband had purchased the "poltergeist house" on Madison Avenue in 2005. She shared an incident where she was sitting on her computer and was able to hear the sounds of someone sweeping repeatedly. The eerie noise, coming from directly behind her, continued

for close to five minutes. To this day, the mischievous spirit on Madison Avenue continues to make its presence known.

I recently had a phone call from a local college student who had been renting an apartment in Heritage Hill. He wanted to keep his location anonymous but stated that we could use his first name, Charles.

Charles moved into his apartment in 2010. Similar to John's story, everything remained peaceful for the first year of his residence. He began to suspect that something was amiss when doors he had just closed would be opened again as soon as he turned around. Paranormal activity continued throughout the next two years but never disturbed Charles to a degree of being intolerable. "It almost became amusing when things happened in front of me or my friends," Charles stated. "It never harmed me, so why should I be afraid of it?"

There was only one incident that managed to unnerve him. He was watching television in his living room one evening when he suddenly sensed that he was not alone. Having had this feeling so many times before, he simply chose to ignore it. Unfortunately, he was not able to ignore what happened next. Just when he started to put the sensation out of his head, Charles was startled by the sounds of a woman screaming from the other room. "It sounded so horrible; bloodcurdling," Charles testified. "It continued for close to a minute."

When I reconnected with Charles two months later, he informed me that he moved to another apartment soon after the "screaming incident." Since he had moved, he shared the location of his former apartment. The address seemed familiar to me. After shuffling through my notes and newspaper clippings, I realized that it was one of the homes mentioned earlier in this chapter. It seems the sound of screaming he had heard was the residual noise of a woman's last moments on earth. In order to protect the anonymity of the victim and her family, I will not share the location. In fact, I empathize with the tenants of this Heritage Hill building and sincerely hope they do not experience the same unnerving experiences as Charles.

GIBBON'S HOME

At the age of thirty-eight, Christopher Gibbons never imagined that he would be living in a haunted house. Married with four children, unseen residents were the last thing he expected to come across when he purchased a home in the local historic district of Heritage Hill in 2004.

The turn-of-the-century Tudor had fallen into disrepair some twenty years prior, but to the Gibbons family, it was a potential dream home. Before they could move into the new residence, several improvements, such as plumbing and electrical, had to be updated. Since Chris worked full time during the day, he spent most of his evenings alone at the house working diligently to get the home into a livable condition. It was not long until he got the feeling that someone invisible was already living in the house. "This sense that someone or something was in the house with me had a certain pressure to it," Chris explained. "It was as if it wanted me gone, like it wanted me to leave…as though it owned the space."

On one of his first nights at the house, Chris shut off the lights and locked the doors; it was late and he was ready to go home. Feeling a little uneasy, he chocked it up to the moonless night. After he backed his car out of the driveway, he looked up toward the house and noticed an interior light had come back on in an upstairs bedroom. Although he knew leaving a light on in such an aged house could potentially be dangerous, the thought of pulling back up the driveway and reentering the house was even more unnerving. He told himself that he was just "too tired to go back in" and quickly sped away from the ominous feeling. Chris stated, "I understood then, as I do now, something, someone, some energy or force existed within my house, and it felt ownership to it."

Chris and his wife continued to fix up the large house, despite their uncertainties about the unseen force. Once the entire family had moved in, their adventure into the paranormal world began. Things started slowly at first, with strange feelings and an occasional unexplained tapping noise. By the following fall, however, the haunting had become much more prevalent.

One of Chris's sons woke up in the middle of the night. He glanced around his room with the strange feeling that he was not alone. Catching movement out of the corner of his eye, he looked over by the window opposite his bed. There, he saw a "white face" that lingered momentarily before dissipating seconds later. Terrified, he pulled the blankets closer to him until he finally drifted off.

The youngest child was the first to report seeing a man wearing a suit as he walked down the back hallway one morning before breakfast. Since then, several other individuals have spotted what is believed to be the same male apparition. The specter appears to be a tall, thin, dignified man, approximately in his forties and dressed in either a white or a black suit.

One evening, the oldest son ran into the kitchen where the rest of the family was gathered. He erratically described an encounter he had just

had with their resident ghost. While playing his guitar, he heard someone clapping behind him in the corner. The clap coincided to the beat of the melody he was playing. The boy knew he was alone in the bedroom but figured one of his siblings was in the next room. He checked the adjoining rooms and discovered that he was the only person upstairs.

It was after this event that Chris began to experience very lucid and disturbing dreams. The dreams consisted of extreme paranormal activity occurring right before his eyes. Coincidentally, as Chris's dreams increased in intensity, so did his fears. "While the taps, pokes and rattling doorknobs about the house were, at worst, an annoyance," Chris states, "I found the dreams to be the most unsettling."

Eventually, Chris confided in his priest about the odd occurrences taking place in his home. He continued to tell the priest about the children's experiences and how upset the household had become. At this time, the priest did little to reassure Chris. He recommended that the family hold a prayer session and insisted that it was best to ignore the activity in the home. The priest refused to visit the home or perform any additional house blessings. This was not the answer Chris had expected. He realized that as far as this situation was concerned, his family would have to handle this by themselves.

In addition to the group family prayer suggested by the priest, Chris began a personal quest of researching the paranormal and, in essence, tried to understand the unseen world surrounding his home. Coupled with his newfound knowledge and the family's continued prayers, Chris traveled upstairs and verbally asked for a "ceasefire." Chris offered up a compromise to the spiritual denizen: the ghost was welcome to reside in the attic and the back of the house, but peace was to be returned to his family. It worked, but only for a short while.

As the years went by, the ghost would occasionally remind the family of its presence. The children often reported being woken up in the middle of the night to find themselves confronted by a face. Chris also encountered this situation. One night, while starting to drift to sleep, he suddenly awoke to find a face hovering directly above him, less than a foot away from his own face. He described the specter's image as being "almost like a mask—white with pitch-black empty spaces for the eyes and mouth."

One incident in particular was cause for Chris to end his compromise. In front of friends, his wife retold a horrific experience she had only days prior. While in the basement doing laundry, she watched as a spectral scene played out before her very eyes. Immobilized, she saw the vision of a man brutally

violating a young girl. When the event finally ended, she fled the house. Chris was angered by the attack on his wife and believed it was quite clear that the implied "ceasefire" was now over.

The next morning, Chris called upon a female shaman and asked for help. The shaman felt the presence of a man who primarily resides in the basement of the home. This made sense to Chris as his dreams always seemed to be staged in the basement, not his bedroom.

The shaman came to the house, and they all took part in a customary ritual. It began with locating the ghost and confronting it. This was followed by creating a spiritual seal on the property to prohibit reentry. They also removed any personal property in the home that was believed to have been owned by the spirit. The ritual concluded with a prayer.

Once the ceremony was completed, the house seemed lighter and quieter. The respite continued for a few weeks, but just as Chris had feared, the entity returned.

Since the purchase of the home, and with it, the induction into the supernatural, Chris has learned many valuable lessons and gained a higher understanding of the ties between his Catholic beliefs and the paranormal. He took those life lessons and penned them into a novella to share with the world.

Chris Gibbons contacted me in 2011 and sent me a copy of his novella. It discussed many connections between religious beliefs and the existence of ghosts that most people may not have considered before. In the end, resolution was reached between Chris and the entity, and the family continues to live in peace in their historical home.

You can continue to read about Chris's fascinating story in his book *Trespass,* published by Morris Avenue Publishing, at http://www.trespassnovella.com.

If you have the desire to take your own look at the architecture in the renowned Heritage Hill, the Neighborhood Association offers a *Self-Guided Walking Tour Brochure* that you can download directly from their website. If you are interested in a more intimate look at the insides and histories of some of these homes, the association offers an annual Heritage Hill Tour of Homes one weekend every May. Each year, approximately ten historic homes or buildings invite the public in for a closer view of the woodwork and elegant artisanship that cannot always be appreciated from the outside. You can find all tour information on the Heritage Hill website: http://www. heritagehillweb.org. If you partake in one of these tours, keep your eyes open and your camera ready. You just may come face to face with a ghost!

CHAPTER 7
HAUNTED DOWNTOWN DISTRICT

It's hard to believe that the downtown area of Grand Rapids began as a small trading post. Over time, it has grown into an exciting metropolis, accented by spectacular cityscape views, bridges, river walks and one-of-a-kind architecture. When writing this book, my intention was to break each downtown location into its own chapter. But as it evolved, I got to thinking; all these locations are within the same historical area. Each street and corner became an intricate part of Grand Rapids' history and its growing society. Every building has its own story to tell. It's an area known for its bustling and a little hustling during the prohibition era. What the people who work and play downtown don't know is that this city has had quite the past. For this reason, downtown Grand Rapids deserves its own chapter.

HAUNTED HOTEL ROW

Most people don't know that where Van Andel Arena's parking lot is today once stood the busiest building in the entire city: the Union Train Station. It was built in 1900 and remained there until 1961, when it was torn down to allow space for the U.S. 131 freeway.

To accommodate the visitors that came to town, a hotbed of hotels, restaurants and saloons stood across the street. Now, three adjoining buildings at 58, 64 and 70 Ionia Avenue are all that remain of these once prosperous hotels: the Crathmore Hotel, American House and Wellington

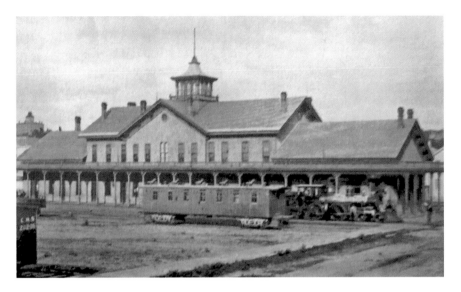

Union Station. *Courtesy of Grand Rapids Public Library Archives.*

Hotel. The number of deaths that took place in these buildings is staggering. The spirit energy left behind from those who died suddenly or unexpectedly has created a flurry of paranormal activity. These three buildings have not only been connected in structure but in the afterlife as well. The following are just a few stories of the deceased; they include suicide, murder and downright mysterious circumstances.

In 1889, the Hansen House was built on the corner of Ionia Avenue and Oakes Street. It was renamed the Crathmore Hotel when it was purchased by Charles and Louis Mertens. While it was considered one of the finest hotels in the city, it was not exempt from having its guests die.

One of the saddest stories took place in 1906. Mary Krol, a twenty-two-year-old woman from Poland, worked for the hotel. She discovered she was pregnant by a man from the west side of town. When she told him, he denied it was his. Mary could barely speak any English and had no one to turn to. Her coworkers said she was frantic and willing to go to extremes to rid herself of her troubles. Instead of living in shame, she chose to jump out of a third-story window and landed head first in a lightwell, an open area of the roof designed to admit natural light into the building. Her skull was crushed.

In 1919, a man named C.F. Kirby was found dead on the floor of his room. While the local police found a bottle of pills, it was never determined if it was a natural death, foul play or suicide.

The American House sat between the Crathmore and Wellington Hotels. It was expanded in 1906 and received a complete makeover before it was purchased by the Merten brothers in 1909.

Prior to these renovations in 1896, George Barton, who was fifty-five years old, was on temporary leave from the Soldier's Home. He wandered into the American House saying he was sick and asked for a room. When he didn't show up to dinner, the proprietor brought him a simple meal of coffee and biscuits around 9:00 p.m. That was the last time he was seen alive. The following morning, the proprietor found him sitting upright in bed, fully clothed but dead. An autopsy found some type of irritant poison in his stomach. His death was ruled a suicide.

In 1902, Edward Parker stepped out of Union Station and asked a patrolman twice for directions to the nearest drugstore. Once there, he purchased his drug of choice: morphine. He was seen later that day at another hotel "acting drowsy." The following morning, he was found dead by the hotel's cleaning staff. Searching his body, they found a device used for automatic writing, a method used for spirit communication. It was discovered that he was a crystal reader and palmist who was in town to attend the annual psychic convention that was taking place in Briggs Park, near the intersection of Elmwood Street Northeast and Lafayette Avenue. When his family arrived to claim his body, officials learned that Parker suffered from an extensive addiction to morphine. He had been without the drug for some time, an action that would have made him quite ill. He may have overcompensated when he finally had the substance in his possession, causing his accidental overdose.

As time went on and the needs of downtown Grand Rapids changed, the American House was no longer used as a boarding establishment. Instead, it was renamed the Judd Building and became a location for various manufacturing businesses. Even though the stigma of a hotel with mysterious deaths lingered away, tragedy still found its way into the building. Soon, 64 Ionia Avenue would be known as the crime scene for Grand Rapids' oldest unsolved murder.

In March 1938, police were called to the Behr-Manning Company located on the third floor of the Judd Building. There, they found the once beautiful stenographer, nineteen-year-old Mina Dekker, lying beaten on the stockroom floor. She suffered five blows to her head with a blunt instrument and had defensive wounds on her hands, as well as a broken finger. Unconscious but gasping for breath, she was rushed to St. Mary's

Hospital. Mina never regained consciousness; she died two hours later. The severity of the attack became obvious when a bone fragment found at the scene was confirmed as a piece of Mina's skull. At the time of the murder, only the first and third floors of the building were occupied. The second and fourth floors were both vacant; it is possible that is why no one heard her cries for help.

Detectives tried their best to reconstruct Mina's last moments; it looked as if she had been filling out an order form on the typewriter when she went to assist someone. The Western Union messenger boy picked up a letter from her office minutes before the attack. He said that Mina appeared startled and kept looking into the warehouse as if she had seen or heard something, but he hadn't seen anyone else in the building.

The assault took place between 12:30 p.m. and 1:30 p.m. while her co-workers were at lunch. Workers at the Manufacturers Supply Company on the first floor remembered hearing the delivery door slam ten minutes before employee Ray Peters went upstairs, and another worker recalled hearing the rear freight elevator.

As posted in the *Grand Rapids Herald* on March 4–16, 1938, there were several suspects in the murder. John Schafer had recently parted ways with Mina after a yearlong relationship, despite their conversations of getting married. He admitted to visiting Mina during the noon hour but had returned to his college campus five blocks away at 12:45 p.m. Later, while securing the scene and looking for evidence, police found a cryptic note written by Mina in her purse. It read, "Do not hurt the next girl you love."

The detectives seemed to have their eyes on another man as well: Calvin DeBlaey, a twenty-seven-year-old truck driver for the Manufacturing Supply Company, who had come into the office minutes after Mina was found. Under suspicion, he had taken two lie detector tests in Lansing; both came back as "inconclusive due to nervousness."

Despite both potential suspects, officials could not find enough evidence to charge anyone for the crime. At this point, it seems justice will never be served for Mina or the family who loved her. Mina Dekker was interred at Restlawn Cemetery four days after she was brutally murdered, her casket covered with lilies and roses.

The Wellington Hotel stood next to the American House. Like its sister hotels, the Wellington had its own share of death and mystery.

In 1899, Alex Odikirk was an unfortunate patron who met his end at this quaint hotel. Testimonies from employees show that while incredibly intoxicated, he fell down the stairs and hit his head on the railing. They

Left: Mina Dekker, March 1938. *Courtesy of* Grand Rapids Press.

Right: The murderer escaped out this back delivery door. *Photograph by Nicole Bray, 2011.*

helped him back to his room and didn't see him until the next day, at which point he had a bloodied forehead and black eye. It wasn't until two days later that he was found dead in his room, blood smeared all over the pillows. The coroner found major lacerations on his head, but it was never determined whether Odikirk died from his injuries in the fall or if he was the victim of another violent assault.

While in the middle of a heat wave in August 1906, a twenty-eight-year-old Polish man named Bert Lubieski was working as a chef at the Wellington Hotel. He complained of feeling ill before collapsing unconscious to the floor. He was taken to Butterworth Hospital, where he died soon after.

The former Wellington Hotel, currently McFadden's Restaurant and Saloon, is also the subject of an interesting legend. During the 1900s, the top floor of the hotel was rumored to be a brothel. One story states that a young working girl fell in love with a client. As her feelings deepened, the gentleman purposely stopped his regular visits with her. Heartbroken, she committed suicide by hanging herself from one of the ceiling rafters. Is this just a legend? Could the story of the Polish Mary Krol from two

buildings over have morphed into this tale over the years? Regardless of who and why, many people died on this small block of land. Current patrons and workers are convinced the tortured souls still haunt these former hotels.

Though the Ritz Koney Bar and Grille occupies the ground floor, 64 Ionia Avenue stands mostly vacant. I ventured in to try and interview staff members about possible paranormal activity, but it seemed a taboo subject. Having overheard the conversation I was trying to have with the bartender, a table full of women motioned me over. A kind lady named Carol started the conversation, "Don't let them fool you. Everyone knows this place is haunted!"

I joined the women for a drink and listened to their tales of how people have seen the figure of a young woman looking out the upstairs window for decades. When I asked if they knew which window she was seen in, Carol responded, "I don't believe it's one certain window. It just always seems to be on the third floor!"

McFadden's was a bigger paranormal goldmine than its next-door neighbor; not one employee seemed to have a problem talking to me about the resident ghosts. According to staff, a majority of the paranormal activity occurs on the third floor. Erik, the daytime manager, was kind enough to take me on a tour of the three floors and basement area. When we were on the third floor, he told me about several different events that took place, including one that he experienced personally.

One evening, he was closing the third-floor bar down. While he was alone in the room, he turned around just in time to see a wine glass shoot off the middle of the bar and crash to the floor twenty feet away. On a different night, another bartender witnessed a napkin caddy sail off the bar and land in the middle of the dance floor. That particular employee quit soon after the incident.

The biggest complaint given by workers and patrons alike is the sighting of a female apparition that most believe to be the suicidal prostitute. Erik pointed out the beam where she supposedly hung herself. Visitors have reported seeing a female figure standing in that general area watching the room or looking out the windows. The McFadden legend states that if you look into one of the mirrors she will often appear, especially if you look into the mirror that has a direct reflection of the mirror behind it. I suppose this concept is not unheard of, as many paranormal experts have used mirrors in the attempt to see apparitions. Generations of spiritualists have used mirrors for scrying, a way to see into another realm.

From left to right: Mcfaddens and Ritz Koney. *Photograph by Nicole Bray, 2011.*

If you are looking for a place to meet up with friends and have a drink and relax, visit one of these local bars and restaurants. Who knows, you may even see a different kind of spirit than the ones on the menu.

SAN CHEZ RESTAURANT

Nestled inside the historic Leonard Building at 38 West Fulton Street is an eatery known as San Chez, A Tapas Bistro. The food is fantastic, and the atmosphere is even better. The Leonard Building was built in 1844 by Heman Leonard. It was originally a grocery store named H. Leonard & Sons.

In 1872, Leonard suffered a massive stroke that left him with partial nerve paralysis. He handed the family business down to his two sons, Charles and Frank. Ultimately, they switched the business from groceries to the production and sales of refrigerators. They constructed their first refrigerator in 1882 with meager materials they had on hand; from there,

business grew and flourished for decades to come. In 1884, their father passed away inside the Leonard Building where San Chez now sits. He was interred in the Fulton Street Cemetery.

In 1951, his sons sold the building to Dykstra Wholesale Distributing, which eventually closed its doors in 1985. The building remained vacant for seven years until San Chez came along with a tapas bistro and Moroccan cuisine that the Grand Rapids area couldn't get enough of. Despite its success, San Chez has a mysterious side, one that most patrons are not aware of, but the staff cannot ignore.

I spoke to a woman named Jill who was an employee several years ago. She told me that whoever is haunting the old Leonard Building is not amused when the kitchen staff outstays their welcome. Several times, when workers hadn't vacated the kitchen area by 2:00 a.m., the pots and pans began to rattle and clang. Despite affirmations from the staff to the resident ghost that they are almost done cleaning up, the activity continues to increase until everyone has left the restaurant.

The apparition of a female has also been spotted in the main hallway. No one knows for sure who she is, but she continues to be seen on a steady basis. Jill also commented, "No one likes the third floor. I am not sure if anyone has seen or heard anything up there, but everyone agrees that they feel uncomfortable; almost as if they are not alone." What is it about the third floors in downtown buildings?

Could Heman Leonard be looking after the building that housed his business and supported his entire family for so long? Or does the building hold another death or misfortune that left a completely different spirit trapped in the historic structure for eternity?

Trust Building

An impressive red sandstone building sits on the corner of Ottawa Avenue and Pearl Street. The home and workshop of William Haldane, who is considered the father of the Grand Rapids' furniture industry, originally stood on the site. It was demolished in 1891 to make room for what was to be the tallest structure in both the city and state. The ten-story office building was completed in 1892. In 1913, additions were made to the south end; a penthouse was added to the top of the building in 1928. People who gaze up at this magnificent structure have no idea of the tragic suicide that took place there and how the building has not been the same since.

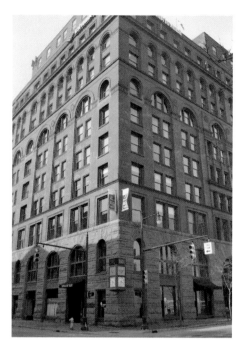

Trust Building. *Photography by Robert Du Shane, 2011.*

A prominent attorney named Niram A. Fletcher, forty-nine years old, kissed his wife and left for work on the third floor of the Trust Building and soon arrived at his firm, Fletcher & Wanty. Fletcher had been in poor health and recently returned from a three-week stay at the Alma Sanitarium, saying he felt much better. When he didn't return home for lunch, his wife assumed he was just trying to catch up on some work. She called his office, but no one knew of his whereabouts. Several people had seen him enter the building as usual, but no one had seen him in his office. For over an hour, his co-workers called around trying to find Fletcher, until an aide noticed a key to the private office was missing.

With a growing sense of dread, the janitor was called to unlock the door. While waiting, another attorney slipped out onto the window ledge to get a glimpse inside the locked room. He was startled to find a gruesome scene and began to scream out to his colleagues. Once the door was unlocked, they found an unconscious Niram Fletcher lying on a blood-soaked couch, faintly breathing. He had apparently snuck into the unused office, slit his own throat with a straight razor and lay down to die. Fletcher was rushed to the hospital, but there was little they could do since he had been profusely bleeding for over two hours.

Fletcher's decision to end his life was explained in a note left on his desk:

> *Why should I not want to live? I have a devoted wife, a mother and niece for whom it has been a pleasure for me to care; a good home, a good practice and friends whose goodness to me cannot be described. I have fought for four years for my health and always with hope until the last three or four weeks. I see nothing before me but a life of hopeless invalidism and of consequent care to my wife and friends. My symptoms*

cannot be described, but I have been wretched with them and see nothing but wretchedness before me to the end of my days.

His autopsy showed that his body was being overtaken by chronic meningitis, inflammation in the tissues surrounding the brain.

Traumas like this create the perfect haunting. It's my opinion that the trapped soul isn't "stuck" from the senseless act of suicide but from the overpowering energy that is created by such emotional trauma. Many skeptics have become believers after working in or visiting the Trust Building. One basic word seems to be used over and over again to describe the feelings you get in the building: *creepy.* Anyone even a tiny bit sensitive to the paranormal world can sense a presence in the building.

A woman named Laura recounted a time where she worked on the third floor and how she sensed that she wasn't alone in the office. "People are always complaining about the feelings of being watched or followed," she states. "This time I just wasn't prepared to see something more than just the walls." Laura had turned around and saw a white-colored mass suspended in the doorway. "I was so scared that I just stood there and looked at it. It eventually disappeared, but I could still feel it around. I didn't like that feeling, especially now that I saw something."

A male worker in the building often witnesses a dark figure walking back and forth behind him. How can he see behind him, you ask? While performing multiple tasks on his computer, it is commonplace for him to see the figure's reflection on his computer screen.

Even Julie Rathsack experienced a creepy visit to the Trust Building:

When I was eighteen years old, I was an intern at a local business downtown. I was sent to make a delivery to the fourth floor of the Trust Building. After walking the block from our office in McKay Tower, I entered the hallway. I could immediately feel heaviness in the air; it felt cold and thick. Quickly, I walked over to the elevator and pushed the up button. I knew I was being watched by someone or something, yet no one was around. Once I entered the elevator and the doors shut, the air turned ice cold. I had this overwhelming sense that someone was standing right next to me. I turned but saw no one. I delivered the package and high-tailed it out of the building. It was more than apparent to me that a spirit haunts the place. After doing a little research, I discovered why I may have felt that way.

Could this specter be the long-departed attorney? Perhaps even in death, he cannot find rest. Many people who have been in the Trust Building think this is not a theory but a fact.

CIVIL WAR MONUMENT

On the corner of Fulton Street and Division Avenue stands a tiny triangular park that marks a historic time in our nation's past. Some people pass this monument without a moment's thought while others recognize its significance and give honor to the 4,214 Kent County men who fought in the Civil War and the 600 who perished. One patriot, however, may never have left the area.

This statue was given the distinguished title of one of our nation's most historic Civil War monuments. It was constructed of white bronze, also known as zinc, and was the first Civil War monument to pay tribute to the efforts of women during the war. It was also the first to include a fountain. Famed cavalry general Philip Sheridan was the guest of honor at the dedication ceremony, which took place in September 1885.

This 1959 photo shows the widening of the street; the monument is visible to the far left. *Courtesy of Grand Rapids Public Library Archives.*

Over the next 115 years, the monument was moved 150 feet to allow widening of the roads. It was also painted many times; the statue was originally created with the Union soldier positioned at the crest of the monument painted dark "Union" blue. Due to time and the elements of Michigan's weather, the blue paint faded, and the soldier soon became Confederate grey. Many citizens thought this was a dishonor to our Michigan Union soldiers and demanded the statue be repainted. By 2000, the fountain had dried up and the small park was overgrown and forgotten.

On Memorial Day 2000, General John A. Logan Camp No. 1, Sons of Union Veterans of the Civil War, kicked off an immense effort to raise over $250,000 for the restoration of this historic treasure. Experts had determined that the monument needed to be dismantled and sent to Karkadoulias Bronze Art in Ohio, where layers of paint could be removed and the cracks and holes repaired. It took three years for the organization to achieve its goal.

When the workmen arrived at the monument to begin dismantling, they were shocked to find that it had never been bolted down. I am aware that the weight of this monument is such that it was never in any danger of theft, but the fact that this historic jewel withstood some nasty Michigan storms and floods and yet never wavered is amazing. It can be taken as a true testimony to the strength of our nation's Civil War soldiers.

Upon completion and delivery of the newly restored monument, a rededication service was held. This two-hour ceremony followed the exact program of 1885, with men dressed in blue and grey and many women in hoop skirts. Citizens of all ages attended, including Michigan's only two known men who can claim their fathers fought in the Civil War, Harold Becker and Edward Blakely. The honor of turning on the fountain went to Blakely; his father was a Tenth Michigan Cavalry soldier who was present during the initial dedication of the monument.

Blakely was diligent with his fundraising efforts to restore this park and memorial. He stated on multiple occasions, "It is my desire to live long enough to see the monument rededicated and to stand where my father did in 1885." On October 4, he was granted his wish. He quietly passed away twenty-four days later, six weeks before his 100th birthday. He was buried wearing his Union Cavalry jacket with the rededication ceremony button and ribbon still attached and with his Union kepi. Edward Blakely not only showed love toward his father but also showed others the importance of paying tribute to the soldiers who fought in the Civil War.

Despite his last wish being granted, some believe that Mr. Blakely remains steadfast at the soldier's monument, even in the afterlife. The apparition of an elderly man staring up at the statue has been spotted by several people, even in the daytime. Author Robert Du Shane truly appreciates the significance of this monument.

"As a civil war reenactor myself, I cannot help but be drawn to this monument; the fact that I have heard from more than one of my friends that they had seen a ghostly apparition in uniform on this corner makes this spot all the more dear to me."

Civil War monument as it stands today. *Photograph by Nicole Bray, 2011.*

A woman named Jennifer told me her story. While relaxing on her lunch hour in the tiny park, she saw a "friendly-looking older gentleman" wearing a Union Cavalry jacket and hat. She smiled and said hello to him as he slowly walked by. He acknowledged her with the tip of his hat and a smile back. Jennifer closed the book she was reading and looked up seconds later. He was nowhere to be seen. "There is no way a man of his age could have walked fast enough to get out of sight so quickly."

Could this be the proud Edward Blakely? His last dying wish was not to see his 100th birthday but to stand where his father did so long ago in dedication to the soldiers he so profoundly respected. Perhaps he still stands guard there today in an eternal testimony of honor and respect.

AMWAY GRAND PLAZA HOTEL (FORMER PANTLIND HOTEL)

In his book *Citizen's History of Grand Rapids*, author William J. Etten wrote, "The spirit of hospitality appears always to have hovered over this City of the Rapids." In 1890, the epitome of "spirit of hospitality" was the Pantlind

Hotel. Grand Rapids had close to forty hotels at the time, but only the Pantlind and Morton Hotel, which is now known as the Morton House Apartments, were considered "desirable."

The Sweet's Hotel was built in 1868 by Martin L. Sweet. In 1902, he sold it to James Boyd Pantlind, who remodeled the entire building and gave it a new name: the Pantlind Hotel. Embellished with every luxury imaginable for that time, including phones in every room, this hotel lobby held the architectural title of the largest gold-leafed ceiling in the world.

In August 1978, Amway Corporation purchased this historic treasure and restored the Pantlind to the original 1920s design. The company also added room for restaurants, shops and large meeting and banquet halls. Today, the Amway Grand Plaza is still known as one of the finest hotels in America. With so many people coming and going, it was bound to witness a few deaths over the years. The following are just a couple examples from the early 1900s.

In 1899, Amelia Rice, the proprietor's wife, died of uterine cancer in her living quarters of the hotel. She left behind her loving husband,

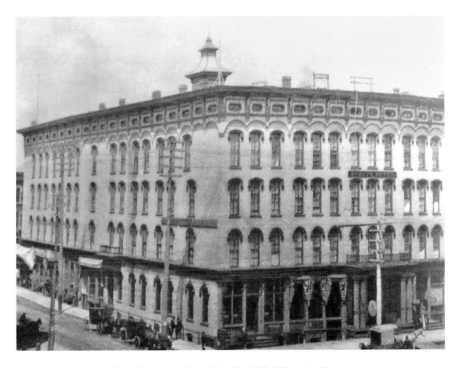

Sweets Hotel, late 1800s. *Courtesy of Grand Rapids Public Library Archives.*

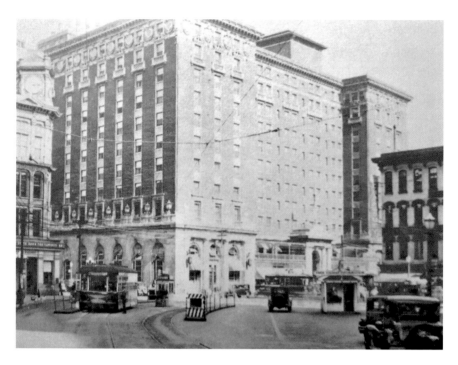

Pantlind Hotel. *Courtesy of Grand Rapids Public Library Archives.*

Judson, and two children, having already lost their third child who died prior to her passing.

In 1906, Hiram Mills was a well-known surgeon at the Michigan Soldier's Home. He and his wife made reservations for four people to have Thanksgiving dinner at the Pantlind Hotel's restaurant. Earlier that morning, Hiram complained of soreness in his chest. However, when they reached the hotel, the pain was at a whole new level. Hiram died suddenly, less than thirty minutes after his arrival.

In 1912, a reporter named Lueve Purcell was called to the Pantlind Hotel for what he assumed was a big new story. He rushed into the lobby smiling, excited at the prospect of catching the latest scoop. Instead, he was met by two hotel clerks who were acting strange. Growing impatient, Lueve demanded they immediately tell him "what the dope" was. Slowly, the workers led him upstairs to a parlor where he found the dead body of his twin brother, Charles. It seems Charles was in the hotel's café that afternoon when he suffered a massive heart attack. Coincidentally, both of the city's coroners were dining just a few tables away and witnessed Charles's head droop and his body go limp in the chair. Despite their best efforts, they were unable to revive him.

Needless to say, Lueve was devastated. Not only did he lose his twin brother, but he lost his best friend, as they were rarely seen apart.

In 1914, a servant girl named Mary Monko was riding in the elevator with her friend and co-worker Josephine Kreuko. They were finished working for the night and headed to their sleeping quarters. Playing around, Josephine grabbed the controls from the operator's hands as her friend stepped off the elevator. Mary's head was caught between an iron gate and the tenth-floor landing. She was decapitated and horribly mangled.

When driving past this structure, I could not help but notice the architectural contradiction. The west side of the hotel features a soaring modern glass design that dominates the downtown skyline. The east side, the original Pantlind Hotel, is built of brick and has an old-world elegance about it.

Jim, a staff member at the Amway Grand Plaza, told me about a mischievous spirit that seems to have an aversion to smoking but only in the old Pantlind Hotel section. "If a guest leaves behind a dirty ashtray, it disappears. If someone leaves cigarettes behind, they disappear. Even if the ashtray has yet to be used, it sometimes disappears."

Colonial Room, Pantlind Hotel. *Courtesy of Grand Rapids Public Library Archives.*

Jim continued by saying, "Guests often state they feel like they are being watched while they smoke in the sitting room. Who knows, maybe the ghost is waiting for them to leave so it can clean up," he laughs. This is the same section of the hotel where a woman's apparition has been seen.

The ghost of a little boy has been seen wandering the hallways. He is known to follow people when they walk down the corridors and disappear as soon as they've caught a glimpse of him.

Back in 1996, I attended a wedding reception in one of the main ballrooms. During the dinner, I struck up a conversation with two workers at the bar. They told me that a few weeks prior they had both simultaneously witnessed a ghostly couple waltzing on the dance floor. The man was in a tuxedo, and the woman was in a sage-green puffy Victorian gown with a hoop skirt. The figures were both so solid that the bartenders thought two people dressed in costume came into the room when they weren't looking. It wasn't until they both disappeared in front of their eyes that they realized they had just seen ghosts.

A woman named Stacia also shared her ghostly tales with me. Having worked at the hotel desk for over a decade, she's heard many customers share their spooky experiences. People have been poked, blankets have been tugged off beds and objects continually move when no one is around. Her favorite story involved an older gentleman who mentioned upon checkout that he had been woken during the night by two loud men carrying on a conversation directly outside of his room. As he unlocked his door to ask them to keep it down, he surmised by the volume that the men had to have been standing inches away from his door. Seconds later, when he opened it up, no one was to be seen.

Could the servant girl Mary Monko still be cleaning up after guests? This would explain why the cigarette trays are emptied and objects are moved about. Are the men's voices in the hallway the residual energy of Lueve Purcell and the desk clerk as they walk toward his brother's cold corpse? We'll never know for sure.

Tragic Church Fire

Father Andreas Viszoczky came to Grand Rapids in 1835 to assist Father Frederic Baraga in the development of a parish for both settlers and the Indians. In 1847, Father Andreas used $1,500 to purchase the Richard

Godfroy house and the land it stood on at the southeast corner of what is now Monroe Center Street Northwest and Ottawa Avenue. The old house became a residence for the priests and, occasionally, their family members. In 1849, a stone church was built on the land next to the home.

Tragically, at 3:00 a.m. on January 14, 1850, a fire broke out that completely destroyed the priests' residence. Father Andreas and his servant managed to escape by jumping from a second-story window. Since they were believed to be the only two people in the house at the time, no rescue efforts were put forth to venture inside the building until the fire was completely out.

The assistant priest Father Kilroy had visitors from out of town, his elderly mother and sister. Not having enough room in his small quarters, several other people in the village offered to put the two kindly women up for the night. They didn't decide until after Father Andreas had already gone to bed to sleep in the room he offered to them downstairs in his home. It wasn't until later in the day when officials uncovered the bodies of two women that Father Kilroy realized the enormous toll the fire had taken. Not only had it burned over 1,800 baptismal records, but it took two precious members of his family. One city official called the disaster the "most soul-harrowing event that ever transpired in Grand Rapids."

Repair of the new chapel commenced and was completed in 1850. Father Viszoczky named the church after his patron saint, Saint Andrew. In the winter of 1872, the grounds on Monroe Avenue were sold to Moses Aldrich, and the stone of the old church was used for foundations in the present cathedral building.

According to people who have worked in this building, the anniversary of the devastating fire seems to spark off immense paranormal activity. Beth Rickland, a former witness, stated that on every January 14, people in the building brace for what has been referred to as "the night of hell." Lights and electronics mysteriously turn on and off. The elevator is also affected, running by itself and not allowing the doors to open. What may not be coincidence is that the activity will cease as soon as dawn breaks, and then all remains quiet for another year.

Locals believe that the souls of the two women who perished cannot rest in peace and choose to act out for one night of the year, in hopes of drawing attention to the anniversary of the fire. Could they be trapped in an eternal struggle to let people know they are still in the building awaiting salvation?

MORTON HOUSE

The corner of Monroe Center Street Northwest and Ionia Avenue has remained an intricate part of Grand Rapids history. Although it is vacant at this time, it has an impressive reputation in the paranormal world.

The first building erected on this property was constructed in 1835 by Hiram Hindsill. It was a two-story structure with a ballroom on the second floor. Around 1850, it was sold to Canton Smith and renamed the National Hotel. In September 1855, the hotel caught fire and burnt down to the ground. It was replaced by a four-story structure built of pinewood. This hotel also burnt down in 1872. Luckily, all three hundred guests were successfully evacuated, and no deaths occurred.

A new structure named the Morton House was built entirely of brick and expanded through the corner property. Times were good for spacious hotels during this period, and the Morton House was no exception. It seemed renovations happened consistently but not always smoothly.

In 1894, William Morgan, forty-eight years old, was the house carpenter for the hotel. He and his co-workers finished installing an outside freight lift for luggage and decided to try it out. Standing to the left of the main entrance, Morgan was knocked down by the apparatus. His head became caught between the lift and the sidewalk. He was decapitated instantly, his head so mangled that he was unrecognizable. A co-worker witnessed the accident and was able to identify him. Morgan left behind a financially troubled wife and six children.

In 1923, the hotel was purchased by James Boyd Pantlind, owner of the Pantlind Hotel. Known for having luxurious rooms, he replaced the old Morton House with a twelve-story fireproof building that contained four hundred rooms, each with their own bathroom. He renamed the property the Morton Hotel.

In 1928, eight local doctors partnered with the Morton House Hotel to create the Burleson Sanitarium. You may be thinking, "A mental institution resided in the Morton Hotel? No wonder it is so haunted!" Wrong! This sanitarium was used for more "colorful" purposes. The entire twelfth floor was dedicated to "diseases of the rectum." Due to declining business, the Burleson Sanitarium moved in 1937 to a less expensive facility in East Grand Rapids.

The Morton Hotel closed soon after. It was then turned into apartments, primarily for low-income people. The building was permanently closed in 2011, due to poor maintenance, including cockroach and bedbug

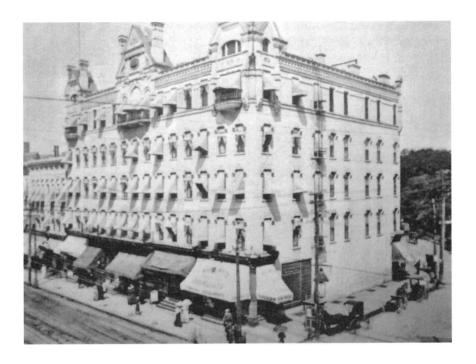

Morton Hotel. *Courtesy of Grand Rapids Public Library Archives.*

infestations. Regardless of its once glorious past, this building is now known for its supernatural surprises.

One unique haunting in this building is not a human entity but of the feline persuasion. The ghost of a cat has been spotted for years roaming the eighth floor. Tenants claim it is the spirit of a cat who was thrown out of a window by a vicious pet owner in the late 1990s. Succumbing to an obviously violent death, this cat seems eternally trapped in the building. Could it be there out of some misguided loyalty to its owner, or is it seeking the love of a good family, one it wasn't able to find during its nine lives?

Many tenants complain of turning their lights off for the night, only to have them turn back on by themselves. There are several apartments in the building where the doors continuously open and close on their own. Items also move when tenants are away and, occasionally, are seen moving right before their eyes.

One tenant, James, recalls a time when he was frightened in his apartment. Settling down for the night, he took off his watch, set it on his nightstand and proceeded to lie down in bed. Slipping peacefully into slumber, he was

disturbed by a slight dragging noise coming from beside him. He hesitantly reached over and turned on the small lamp next to his bed. It brightened the room just in time for him to see his watch slowly slide the remaining few inches before falling to the floor.

I received a short e-mail from a woman named Rose. She commented that the most active place in the building was on the "Mez Floor." Housing only a limited number of tenants, this floor has the same issues previously mentioned and so much more. A female apparition has been spotted on multiple occasions, always disappearing the second you look at her. Her visitations often coincide with a cold draft or temperature drop in the room. Could this be the spirit of William Morgan's widow looking for her husband at his workplace, the last time she saw him alive? No deaths were reported during the fires on the land, but with so many occupants over the years, no one can give an accurate estimation of the lives lost on the property.

FORMER DAVENPORT BUILDING

The corner of Division Avenue and Fulton Street has hundreds of people scurry past on a daily basis, but very few know about this corner's tragic history. At one point in time, two hotels sat at this intersection. The six-story Livingston Hotel was built in 1887 on the former Judge Lovell Moore homestead. Directly across the street was the Cody Hotel, built the previous year of 1886.

With the advent of public transportation through the area, both hotels lost their "family-type patronage." From that point on, the Cody experienced countless name changes and ownerships. In 1946, it was closed due to a fire and reopened in 1948. It remained in business until 1958 when it was razed to make way for the No. 2 municipal parking ramp.

The Livingston Hotel does not hold such a mundane past as the Cody Hotel; instead, it bolsters a troubled one. In 1907, the bleak history began with the suicide of a man from Chicago. He checked into the building, suffering from what looked to be the final stages of consumption but never checked out. He was found in his room in a puddle of blood. He had slit his own throat with a straight razor and then fell back on to the bed where he slowly bled out.

In 1909, seventeen-year-old William O'Brien was the elevator conductor for the hotel. Having been asked to deliver a note to the fifth floor, O'Brien stepped into what he believed to be a dark elevator. Unfortunately, it was

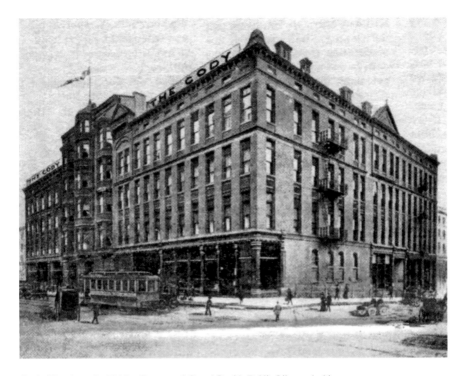

Cody Hotel, early 1900s. *Courtesy of Grand Rapids Public Library Archives.*

nothing but the elevator shaft. He plunged down four floors onto the concrete bottom and died soon after.

In 1913, Herman Lansing collapsed in the lobby of the Livingston and was rushed to Butterworth Hospital. He had complained earlier in the day to a worker there that he wasn't feeling well and was taking a stimulant for his heart. At his autopsy, he was found to have strychnine in his stomach. It was never proven whether it was suicide or an accidental overdose.

The building suffered from neglect, and the ever-changing management never stuck around long enough to do anything about it. Small updates were made but nothing close to the maintenance it needed. Even some of the local officials deemed the Livingston Hotel "a firetrap." Unfortunately, on April 1, 1924, that is exactly what it became.

The newspapers described it as a "nighttime holocaust." Shortly after 10:00 p.m., a guest rang down to the chief clerk in the lobby and commented that he detected the scent of smoke. When the clerk ventured up toward the guest's room to investigate, he too could smell it. Believing it

to be an elevator motor, he traveled downstairs. Upon opening up a men's bathroom door, he was assaulted by flames. The clerk ran to the lobby and sounded the alarm.

Soon guests were seen screaming and running for the fire escapes, where they remained until the firefighters arrived. Some leapt to the roof of the adjoining building of the *Herald*, which was anywhere from one to three floors below them. Two women were found lying on the roof of the *Herald*; one later died at Saint Mary's Hospital from internal injuries.

Gyles Wade, a seventy-year-old painter, was last seen by the elevator boy on the sixth floor. Wade refused an offer to ride down in the elevators, a choice that would have saved his life. Instead, the brave man spent his last moments on earth helping other guests and staff, a true hero. His body was found days later in the ruins.

At 2:00 a.m., the fire department, unaware that there were already five fatalities, declared the fire to be under control. By daybreak, city officials reported that five people had died, many others were injured and two people were still missing. The death toll would soon rise to eight and the number of injured to ten. The local papers also mentioned that those who died did so as a result of jumping to their deaths or burning to death.

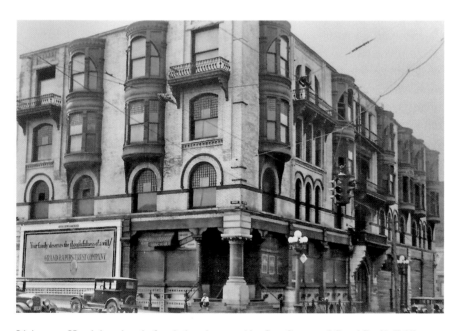

Livingston Hotel, just days before being destroyed by fire. *Courtesy of Grand Rapids Public Library Archives.*

Prosecutors and fire officials immediately suspected that something "wasn't right" about the Livingston Hotel fire and began massive interviews of all surviving staff and guests. Suspicion quickly turned to Mrs. Grace Morrow, the proprietor of the hotel. It was discovered that Mrs. Morrow was in the process of losing her lease to the hotel, and over $1,000 in furniture had already been seized by a creditor to satisfy a debt. She had other debts she couldn't pay, such as the laundry bill ($395), the coal bill ($1,100) and her last payroll to employees.

Eyebrows rose when Mrs. Morrow admitted that she was inside the Livingston Hotel when the fire began. A staff member testified that after the fire was discovered, Mrs. Morrow was spotted standing at the front desk, smiling. She, of course, denied this. She also failed to admit that she had recently purchased a fourth insurance policy to cover fires, with a payout of $15,000. In addition to this policy, she also had three other policies totaling over $18,000.

The true origin of the fire was never determined. Prosecutors suspended the case and placed it on indefinite hold, with Mrs. Morrow continuing to be the main "person of interest."

What was left of this structure was soon razed and the area used as a parking lot for the next eight years. In 1932, Consumers Power Company purchased the lot and erected an office building. It continued to operate in this structure until it was purchased by Michael Davenport, who turned the building into the Davenport College of Business. Eventually, the college outgrew the building and moved out.

An unoccupied building is all that remains on the land. But for one young man, it became more than an empty space; instead, it became an experience that he will remember forever.

Jared, a local college student, was venturing around the annual Art Prize event, perusing the various art submissions positioned throughout the downtown area. Taking a break from walking, he stopped to rest and took a peek inside the old Davenport building's window. He was not prepared to see an elderly gentleman peering back at him from the middle of the room. Thinking he was witnessing the reflection of someone standing on the street behind him, he turned around. Only a few people were close to him, none of whom resembled the old man.

Looking back, Jared was shocked to see the man still there, only this time, he was closer to the windows. Jared could easily make out the gentleman's features and clothes. He described the elderly man as wearing old-fashioned clothing with a full head of white hair. The man's eyes seemed sad and appeared to look right past Jared.

Did Jared witness the spirit of a fire victim? Some speculate that if a person in life has any unfinished business, he or she can become bound to this world. Perhaps this entity was the kindly old Mr. Wade who gave his own life to save others on that chaotic night.

THE DARK TUNNELS OF GRAND RAPIDS

A myriad of people may be aware of Grand Rapids' history and its ghostly inhabitants but would be surprised to discover what lay underfoot. Throughout downtown, Grand Rapids has hidden tunnels that run from building to building. Some of these passageways are still a part of daily life while others are a long forgotten part of Grand Rapids' past.

These tunnels were first utilized in the mid-1800s and were a mainstream for water, gas and steam distribution throughout the city. As technology evolved, the tunnels were used to run electricity, telegraph and telephone lines.

The least known underground systems are called "area-ways." These are sometimes mistaken as part of the main tunnels when, in fact, they do not connect. Referred to as the "mysterious and spooky subterranean part of Grand Rapids," they are rumored to have been part of the Underground Railroad. This story is just a myth, however, as the Civil War was finished long before these subversive mazes were created.

One could find it coincidental that many of the haunted locations mentioned in this book are connected by these tunnels: Morton House, Amway Grand Plaza Hotel, Ritz-Koney, McFadden's, San Chez Bistro, Trust Building, Saint Cecilia Music Center and the Michigan Bell Building. The fact that all these buildings are considered extremely haunted and *just happen* to be connected underground does seem to be a little more than a mere coincidence. Could this be a ghostly version of a conspiracy theory? We'll never know!

CHAPTER 8
St. Cecilia Music Center

Location: Ransom Avenue Northeast

Located in the middle of downtown Grand Rapids is the Saint Cecilia Music Center. This building was built from the ambitions and dreams of nine determined women; thanks to them, we have been blessed with this magnificent building, its nearly perfect acoustics and its ghosts.

The Saint Cecilia Music Society was formed in 1883. During this time, Grand Rapids was booming as the nation's "Furniture City." This prosperous era allowed many women time to indulge in their interests—in this case, the love of music and the arts.

The group began small, and it would perform for one another in their homes. Soon after, the women were bringing internationally renowned musical artists to the city to perform for the general public. As membership grew, the women decided to raise funds to build a permanent home for these performances. Through fundraising efforts such as chicken dinners and calendar sales, the society had enough money by 1894 to build the hauntingly beautiful building that we know today. The main goal of the group was to promote the study, education and appreciation of music. With such a pure and lofty purpose, what name would fit better than Saint Cecilia, the patron saint of musicians?

Before we discuss details of the haunting, I think it's important for you, the reader, to know the legend of Saint Cecilia. She was born the daughter of a patrician in Rome. As was the custom of the times, she was forced to marry

against her will to a man of her father's choosing. This man happened to be a pagan whose name was Valerian. This forced ceremony set this otherwise ordinary girl on the path to sainthood. On the day of her wedding, she sat alone, singing to God. She offered up each of these songs as prayers for help.

That night, when the guests had returned to their own homes, and Cecilia was alone with her new husband, she let him know of her desire to remain pure. She went on to confess that she already had a love. This love was not a human one but rather an angel of God, who was very jealous.

Valerian was shaken by suspicion, fear and anger and said to her, "Show me this angel. If he is of God, I shall refrain as you wish. But if he is a human lover, you both must die." Cecilia answered, "If you believe in the one true and living God and receive the water of baptism, then you shall see the angel."

Valerian listened and, at his wife's direction, set out on a quest to find the bishop named Urban, who later became Pope Saint Urban. Like most Christians at the time, the bishop was hiding among the tombs of the martyrs, as this was a time of persecution for them. Valerian found Bishop Urban and professed his faith, was baptized and returned to his wife.

When Valerian arrived home, he found an angel with flaming wings standing beside his virginal bride, Cecilia. The angel greeted Valerian and placed crowns of roses and lilies upon their heads. Soon after, Tiburtius, Valerian's brother, also converted to Christianity. He too experienced many signs from God after he was baptized.

Valerian and Tiburtius devoted themselves to the Christian community and saw to it that anyone who died for believing in Christ received a proper burial. One day, the two brothers found themselves in trouble for refusing to sacrifice to the false god, Jupiter, and were sentenced to death. Maximus, the Roman officer who was to oversee both executions, witnessed a vision and converted to Christianity one hour before the killings were to take place. Maximus professed his Christianity and, as a reward, was killed with Valerian and Tiburtius. It fell on Cecilia to see that the three men were buried, an act that resulted in her arrest.

A high-ranking official came to her home and tried to reason with her but found her firm in her faith and scornful of his threats. He gave the order that she was to be put into her bathtub and submerged in boiling water, an action that failed to end her life. Irritated, the official decided on another course of execution: Cecilia would be beheaded. Still in the tub, a soldier struck at her neck three times and left her, for it was against the law to strike a fourth time. She lingered on for three days, during

which time Christians who had remained in Rome flocked to her house. As Cecilia lay in great pain, she continued to sing the praises of God. She bequeathed all her belongings to the poor, except for her home, which was left to the bishop for a Christian place of worship. She refused to die until she received the Sacrament of Holy Communion. Upon receiving it, she passed away. Saint Cecilia was buried in the crypt of the Caecilii at the catacomb of Saint Callistus.

In the fourth century, Saint Cecilia Church was built in Rome and rebuilt in the eighth century by Pope Paschal the First. This is when Saint Cecilia showed that her faith transcended death.

Pope Paschal wanted to find the remains of Saint Cecilia and return them as relics to Rome to be preserved in the church. After a fruitless search, he resigned himself to the fact that her remains were stolen when Rome was pillaged in 735. Shortly after the order to quit looking was issued, the saint herself appeared in a dream to Pope Paschal the First. She commanded him to continue his search for her precious remains, an order he intended to keep. He ultimately discovered her body in a cemetery that was fittingly named after her.

Saint Cecilia's corpse was found enveloped in cloth of gold tissue, and at her feet were pieces of linen saturated with blood. Her body was relocated, as well as that of her husband, Valerian; Tiburtius; and Maximus. Pope Paschal also relocated the holy popes Saint Urban and Saint Lucius to the church of Santa Cecilia in Rome.

Saint Cecilia and her accompanying saints were once more unearthed in 1599 during another church restoration. In order to avoid any further disturbances of the saints' bodies, Pope Clement ordered a magnificent shrine of silver to be made for the holy relics, which is where they remain to this day.

In dedication to the brave saint who loved God and sought comfort through music, the building was named the Saint Cecilia Music Center upon completion in the spring of 1894. Once it was dedicated, it was recognized as the only building in the world built by women solely for the study and performance of music.

Near the end of the nineteenth century, this classic-style building would play an important role in American history. It became the local meeting place for the National American Woman Suffrage Association (NAWSA). Founded in 1890, the NAWSA united two suffragist organizations and advocated for women's right to vote and own property and helped prevent discrimination in employment.

This small group of women was responsible for bringing the NAWSA to the citizens of Michigan. In April 1899, the National American Woman Suffrage Association held its annual national convention at Saint Cecilia's, the only time the convention was held in Michigan.

Throughout the years, the Saint Cecilia Music Center has birthed many other art and music organizations around the city of Grand Rapids, including the Grand Rapids Symphony and the Civic Theater.

The two-story building has undergone countless restoration projects throughout the decades. During the 1974 remodeling, the society decided to honor the Royce family, major benefactors to the organization. The hall was renamed the Royce Auditorium.

The West Michigan Ghost Hunters Society has had the privilege of investigating this captivating building on several different occasions since 2010. I spoke with a number of the employees and found that most of them believe there is a potential haunting in the building. Our group asked the staff to keep an ongoing journal of paranormal activity that is experienced within the walls of Saint Cecilia's by employees, performers and visiting patrons.

During our investigations, we were able to capture evidence that supported many of the claims others have made. In addition, almost every team member experienced something paranormal during the night.

The most prominent specter in this historical building is an unknown female that has repeatedly been witnessed on numerous occasions in the Royce Auditorium. She is described as being dressed in Victorian attire and seems to change seats throughout the auditorium. The husband of a former employee, who was attending a concert in the Royce Auditorium, experienced a sighting. During the concert, he excused himself to use the restroom. When he returned, he found a woman in a Victorian dress sitting in the seat next to his, two seats from his wife.

Another sighting of this mysterious woman occurred while a group from out of town was rehearsing on stage, preparing for their upcoming performance. They were unfazed when they noticed a woman walk in the back of the auditorium in a dress that they described as "looking like she was in costume." She gently walked over and sat down. The group kept playing and, moments later, looked up to find the woman gone. The musicians ceased their practice and began to discuss what they all had just seen. Everyone saw her enter, yet no one saw her leave. She simply vanished.

Though we did not see a Victorian-era woman, we did experience a couple unique occurrences in the Royce Auditorium that may validate some of the

staff's claims. During our investigation, we carefully checked the auditorium and made sure all the seats were in an upright position. This would make it easy to document if a seat was unexplainably down, perhaps the work of an unseen visitor. During our second investigation at Saint Cecilia's, this experiment paid off.

Our team was on the stage performing an audio session in hopes of capturing some electronic voice phenomena (EVP). After the first session, I entered the auditorium to make a visual inspection of each seat. They were all still in an upright position.

The decision was made that I would join the men for the next EVP session. Just before we started the recorders, we heard a loud creak from the back of the auditorium. We asked whoever made the sound to please make it again, but the sound did not repeat. I decided to quickly recheck the seats and was surprised to find that a seat in Row Q was down. It was not something that could have happened itself. I tried several times to "set it up" to fall by itself, to no avail. It would have taken some force beyond that of gravity. We cannot help but wonder if the Victorian ghost saw us up on stage and thought there was a new performance to be seen.

Another interesting incident took place on a performance night. A current employee was selling tickets for the night's concert, each ticket naming the seat assigned to the patron that purchased it. As the tickets were being sold, she soon realized that every ticket numbered 105, which is located near center stage, was missing from the stack. This would have been easy to explain away as a printing error if not for an EVP captured by WMGHS. While sitting in seats 104 and 106, two of our members were recording an EVP session when they caught a male voice on their recorder, which was sitting on seat 105 say, "Move it." This EVP can be heard on the WMGHS website.

A former administrative employee wrote in the journal of a time when she arrived early to get some extra work accomplished. While in her office downstairs, she heard symphonic music being played but knew no one was scheduled to be in the building. Curious, she went to see who was upstairs. As she got closer to the auditorium doors, she realized she could also hear dancing. When she opened the doors to the auditorium, it was completely dark, and the music stopped instantly. All that remained was blackness and total silence in the dark performance hall. She had no idea who had been performing, but it was obvious to her that she had just listened to an otherworldly concert.

Another spirit seemingly haunting Saint Cecilia's is that of an unknown janitor. According to the staff's journal, during an African music ensemble,

one of the performers went backstage, where she found an older gentleman in an old-fashioned work uniform. They made eye contact, and then the man went about his business—until he disappeared right in front of her eyes. Other performers have also encountered the spectral janitor. One performance group, in particular, wanted to file a complaint with the building manager. While in the back room preparing to go on stage, a janitor was sweeping in front of the door they needed to go out. They asked him to move, but the defiant man did nothing but shoot the musicians a nasty look. They described the man as an African American male, older and dressed in a one-piece work jumpsuit. Imagine their surprise when the building manager told them that the Saint Cecilia Music Center did not have a janitor or, in fact, any males employed at that time.

The catwalks up above the auditorium seem to fascinate at least one mischievous entity. A former lighting technician was in the auditorium alone working on the lighting board, when suddenly Styrofoam balls began flying out from the catwalks above the auditorium. They seemed to be aimed directly at him. No one could explain the incident, nor could anyone figure out where the Styrofoam balls had come from.

Eerily, a former employee claims to have found a rotting noose in the catwalk area during the renovation. This same employee, who worked alone in the evenings, stated that around the same time every night, the door to the room behind his office would open and close on its own.

Another area of interest is the music library, nicknamed by the staff "the panel room." Many visitors to this space walk out disliking the feelings they get. During the WMGHS investigations, little more than a few EMF spikes were documented in this room. However, for a young couple that attended the WMGHS Halloween event at Saint Cecilia's, that was not the case. Our tour proved to not only satisfy their desire to experience the paranormal but also to downright scare them out of their wits.

A couple was seen running upstairs from the basement level in a fevered state. When asked what happened, the man told us that he and his girlfriend were in the panel room alone when they captured a female voice laughing in the room—a voice that was not his girlfriend. The laugh was so ominous that it can only be described as cackling. It gave everyone in the room chills.

Where do these spirits come from? While doing research into the possible source of these entities, WMGHS was given a news article that might give the identity of the mysterious Victorian ghost. It tells of a female performer, Mrs. W.A. Greeson, who died as a result of a routine operation at Saint Mark's Hospital. Up until the time of her surgery, she had been busily

engaged in perfecting her performance for a recital the following Friday evening. The recital was to take place in the Saint Cecilia Music Center.

Mrs. Greeson had not been ill prior to the operation. This added to the shock felt by friends and family after her sudden passing, just nine hours after surgery. Many of the locals denounced the operation and publicly labeled it a "professional murder." Maybe Mrs. Greeson has returned to the auditorium to carry out her show. Maybe she is eternally mourning her lost opportunity to perform in this magnificent hall.

If you were to ask if the historical Saint Cecilia Music Center is truly haunted, it is likely that you would get a "yes" from former and current staff members, performers and those who have investigated it, including West Michigan Ghost Hunters Society, the Michigan Nightstalkers Paranormal Investigation Team, Michigan Paranormal Alliance and WPARanormal Investigations.

CHAPTER 9
SPIRITED RESIDENTS

FISHING FOR GHOSTS

Late in 2003, the West Michigan Ghost Hunters Society received a frantic call from a woman named Lindsay. She had recently moved into a house located on Houseman Avenue Northwest. The simple home looked like many of the others on the road. Nothing stood out as a warning that she was about to share her home with more residents than she intended to.

Lindsay talked almost hysterically about seeing several "people" in her home. The activity always seemed to present itself in the same area of the house: the main hallway. She described seeing entities of all ages and dressed as if they were from different times walking through her hallway and disappearing. Her family seldom saw the same entity twice. Whenever her family was about to receive a visit from beyond, the living room, which opened up to the hallway, would become extremely cold. Sometimes a noticeable breeze would then accompany the burst of frigid air. Once the entity had passed through, the room would return to its normal temperature.

Lindsay commented that the first time she witnessed this activity, she was sure that someone had broken into the house. "The first time it happened, I just saw it from the corner of my eye. When I looked up, it was gone." Thinking that her eyes were playing tricks on her, Lindsay continued to watch television and tried to get the image out of her head.

Minutes later, another figure appeared. Lindsay jumped up, now convinced that someone had invaded her home. She did indeed have an

intruder—not of this realm but rather of the paranormal kind. "As soon as I ran into the hallway, this figure was gone. I ran from room to room but found nothing. This was the moment I began to question what was happening in my home."

After a short period, Lindsey noticed that one of her visitors might have decided to stay in her home full time. This otherworldly resident seemed as if it had a fascination with the end piece of a fishing pole. Lindsay first made notice of this guest when she walked into her bedroom and spotted the pole resting on top of her bed. She thought it was odd because she was the only person in the home at the time. She simply moved the pole back down to the basement and laughed it off as a prank by her kids.

It soon became obvious to the whole family this was not the product of childish high jinks. Throughout the subsequent weeks, the fishing pole would turn up in unique places throughout the house such as in the bathtub, in kitchen cabinets, eventually in every bedroom, various areas of the basement and one time in Lindsay's car. If the family threw the piece of rod outside in the backyard, the next day it would be found back in the house.

"I remember one incident where I was sitting in the living room watching television," Lindsay recounted. "Everyone else was in bed for the night, and I suddenly heard a clank-type noise. Sure enough, I looked down and that darn piece of fishing pole was now sitting on the coffee table!"

It was shortly following the incidents with the fishing pole that the family started to observe the visitors in the hallway of their home. This constant unnerving intrusion is what prompted her to contact a paranormal team.

When we arrived at the small home, we situated our equipment in the living room and hallway in hopes of spotting one of these supernatural visitors. WMGHS began our investigation with a short tour of the house; the tour would begin with our first viewing of the elusive fishing pole. Lindsay escorted us into the kitchen, where she pointed to a chair sitting in the corner, but she abruptly put her hand down. According to our client, the fishing pole had been sitting there before we arrived. Now, it had disappeared.

The hunt was on for this cursed item. We searched the main floor and found nothing, so on to the basement. At the bottom of the steps stood two doorways: one to the right, and one to the left. We all walked into the room on the right, which was the laundry room. It took only moments to spot the fishing pole on the floor. As we all gathered around it, we heard a loud noise come from the other room in the basement; something had fallen. We all spontaneously turned our heads toward the noise and began to speculate what could have made the sound. When we looked back, the piece of fishing

rod was gone! The object would have had to get past four investigators as well as Lindsay to physically leave the room.

Determined to find the pole and the source of the noise we ventured to the room on the left of the stairs, which had been used for storage. There, we found the fishing rod sitting on a piece of glass from a discarded table. Had this heavy metal fishing pole been placed with the force we had heard, the glass should have broken or, at the very least, chipped, but the table was undamaged. The message, however, was clear: whatever this entity was, it obviously did not want us touching its valued possession.

Later that night, two of our investigators were sitting at the kitchen table working on documentation when they felt a sudden blast of cold air. When I entered the room only moments later, I was immediately hit by a second blast of ice-cold air. We did everything we could to find a logical source for this breeze. We searched the house for drafts, breezes from the attic and open windows. We could not find a non-paranormal source for frigid blast.

When WMGHS investigator George Bray moved from the kitchen to the hallway, a third burst hit us. He remembered Lindsay saying that when the cold air enters the room, spirits can be seen walking in the hallway. Thinking fast on his feet, George began taking photographs. In one photo, he captured a yellowish-orange colored vortex spanning from the beginning of the hallway near the bedrooms and moving toward the middle of the hall.

According to the Unexplained Mysteries website at www.unexplained-mysteries.com, the definition of a vortex is as follows:

> *An anomalous form that can appear on photographs taken during paranormal investigations that some believe to be a gateway or door to the spirit world and the center of an associated paranormal disturbance. Vortices usually appear as a long whirlwind or column of light in a photograph. Some investigators and mediums believe the vortex can be used as a way for spirits to travel to and from the spirit world to our own world.*

Did we capture on photograph the very moment one of these "doorways" opened? A vortex would explain why Lindsay and her family consistently witnessed entities walking through their hallway.

Soon after our investigation, Lindsay decided she had experienced enough. She moved her family into a new home. Months after she had moved, I followed up with her to make sure all was well. She graciously thanked me and stated that they had not had a single strange occurrence

since leaving the home on Houseman Avenue. As for the piece of fishing rod, Lindsay left it behind when she moved. "Whoever the spirit is that loves it so much can have it."

No Locks for This Ghost!

Bill and Darlene, eager to start their lives together, purchased a fixer-upper that was built in the 1930s in Kentwood. Determined to make this their dream home, they began renovating with what little money they had. What they did not realize is that, along with all the dust, they were stirring up were some nasty spirits as well.

When this couple was interviewed for an Internet blog, they both said they felt uncomfortable in the house as soon as they moved in. They initially assumed it was because they were in an unfamiliar home and that the feeling would dissipate as they became familiar with their surroundings. Unfortunately, this would not be the case, and instead, things escalated as time went on. The activity seemed particularly strong when Bill left the house to attend his third-shift job at a local factory.

Early one morning, Bill arrived home from work and headed to bed. He climbed the stairs and found the large closet door at the landing was open and the light on. This closet had the only access to the home's attic, which was also open. He remembered thinking it was odd but assumed Darlene had left both doors open to air out the attic. He turned off the light, shut the doors and went to bed.

For the next week, each time Bill would return from work he would find the closet in the same state. He asked Darlene if she was playing a prank on him, but she claimed to have no knowledge of what was happening and said she never heard anything out of the ordinary during the night.

Determined to put an end to the irritating occurrences, Bill installed locks on the closet door, as well as the attic access and took the keys with him to work. When he came home the next morning, he found them both open once again; this time, however, the items from the closet were strewn about the floor. As he picked up, he found an expensive diamond watch sitting on top of one of the piles. He did not know who owned the watch, but he did know it was not either of them.

Shortly after the attic activity began, Darlene received a visitor when she was home alone for the night. She answered the door to find a pale-skinned woman dressed in a light blue silk dress with white gloves and a straw hat

standing there. The woman explained that she grew up in the house and wondered what it now looked like inside. Not seeing any harm in granting the woman's request, she allowed the lady to enter the home and look around. When they reached the living room, the mysterious woman asked, "Are you happy in this house?" Darlene responded, "Yes!" At that point, the woman showed a weak smile and turned to leave the house. As Darlene watched her go down the walkway, she noticed the woman was not walking, but floating. A shiver ran down her spine as she came to the realization she had likely just had a visit from a ghost from the home's past.

Eventually, the spirits in the home began to make their presence known throughout the entire second floor. One night, when the couple was in their first floor bed, they started to hear heavy footsteps on the hardwood floors above. Startled, Bill snuck out of bed and quickly locked the door to the stairway that lead upstairs. They listened to the unknown intruder as he walked down the steps and stopped at the locked door. Suddenly, they could hear the sound of a lock being manipulated. The couple sat in stunned silence as they heard the door slowly open and the footsteps continue. Apparently, whoever or whatever was in the house was not going to be stopped by mere locks!

After several more months, the haunting moved to the basement. Darlene began to hear faint noises, such as rustling, coming from under the floors. Already nervous because of the strange occurrences in her home, what was now happening was beginning to unnerve her even more. To help his wife feel more at ease while he was gone, Bill installed a lock on the basement door and routinely wedged a solid oak table leaf under the doorknob.

One night, while relaxing in the living room in front of the television, Darlene was startled by the sound of anguished cries coming from the basement. She froze in horror. After the cries ceased, she heard the sound of heavy footsteps ascending the stairs toward the main floor dining room. Darlene knew the door was locked, but that offered little comfort, as she also knew this entity haunting her home had never let a lock stop it in the past. She heard a sudden loud bang, which she described as being like the shot from a gun. Terrified, Darlene bolted from the house and ran all the way to the factory where her husband was working.

Darlene returned home with Bill in tow. They were startled to find the leaf of the table completely broken in half. They assumed that whoever or whatever had climbed the steps following the screams had broken it. They became even more concerned when they discovered that the basement door was still shut and locked. The couple feared that whatever spirit was residing

with them in the house did not want to share its home and its determination to get them out was only going to get worse if they stayed.

With a heavy heart, the couple gave up their dream house and moved a few miles away. They both drive past the old house from time to time and continue to wonder who haunted them and, more importantly, what will become of the next unlucky people who buy the place.

'TILL DEATH DO WE NOT PART

Christine and her husband, Jack, lived in a charming 1950s-era home. It was located on Frontenac Street, a small connector road between Division Avenue Southeast and Jefferson Avenue. At the time they moved in, the neighborhood was still in the process of being developed; in fact, the road was still unpaved. Nevertheless, the couple immediately fell in love with the home, unaware of how it would come to change their lives.

I made contact with Christine after reading about her story on the Internet. I e-mailed her to see if she would be interested in talking with me about her experiences. I was more than pleased when she agreed. The amount of personal experience she was willing to share simply blew me away.

She explained that several years after moving into the home, Jack suddenly passed away. This left her in the home with her two teenage children, Kim and Chad. I was quickly able to surmise that Christine was a very levelheaded woman who did not give in to flights of fancy. It was due to the evidence of her sharp mind that the stories she would soon tell about the poltergeist activity in her would be taken all the more seriously.

Not knowing where to start, I asked her to share with me the events that stuck out the most in her mind. Christine said quite simply, "The lights; it loved to play around with the lights."

One night while Chad was sleeping upstairs, Kim arrived home late and performed her nightly rituals, turned off her light and snuggled into her warm bed. Just as she was drifting off to dreamland, her brother's light turned on. Since his room was directly across the hall, she could not help but see the beam of light that spread into her room. Not pleased with the disturbance, she called out for her brother to turn off his light. Receiving no reply, she stomped into his room only to find he was still asleep. Deciding not wake him, she turned off his light and returned to her room.

Five minutes later, the light again illuminated her room. She was now convinced that Chad was playing a prank on her. She got out of bed and

went to his room, screaming the whole way. Once again, she found him still in bed, and this time she not only turned the light off but also jerked the plug out of the wall before returning to her room once again. Exhausted, Kim flopped on to her bed.

Ten minutes later, the lamp turned back on. Now thoroughly upset, Kim barged into her younger brother's room. She startled him awake, and he was greatly confused by her outburst and insisted he had nothing to do with light turning on. Looking closer, they both realized that the plug was still resting on the floor! According to Christine, both brother and sister came tearing down the stairway and slept downstairs for the remainder of the night.

The teenagers were not the only ones who had an experience with the mischievous entity that loved to manipulate the lights. Christine recalled, "I was upstairs collecting the dirty laundry when the lights suddenly went out," Christine continued, "I looked around, thinking one of the kids must be playing a joke on me, but no one was there." Still not completely convinced that she was alone in the house, she decided to match wits with the unseen prankster and yelled, "You better turn that light back on before I break my neck, or you'll be grounded until you're forty-two years old!" Immediately, Christine heard the switch on the wall audibly click, and the light went back on. Looking around the room, she found exactly what she had already known: she was completely alone.

Christine feels confident that the spirit roaming the house is that of her late husband, Jack. While she regards him as a dear man and great father, he was always very set in his ways. Every night, like clockwork, he would sit down to watch the 11:00 p.m. news before retiring to the bedroom. Christine explains, "If anyone was still up at this time, they better be darn quiet, or he'd get a little upset and they'd hear about it!"

Christine testified that whenever a family member did something in the house that they knew Jack would not approve of, a strange incident would happen. Her memory stirred up one such occurrence. While Chad was home from the Army Reserves, he suddenly remembered that he had to get a haircut before his Reserve meeting that weekend. Although it was already after 1:00 a.m. on a Friday night, Christine sat her son down and started cutting his hair.

Soon, they were both taken aback by a sickening odor. The haircut came to a halt while they searched to find the source. They never located it. Christine described the smell as "almost like the sewer burped or something. The odor was so strong that it made our eyes water!" Knowing the temperature was cold eliminated the possibility of a window being open, so the smell couldn't have come from outside. After about thirty minutes, the smell simply

disappeared. The following day, Christine called in a plumber, convinced there must have been a sewer backup. The plumber checked everything out but found nothing in disrepair. He had no idea what the smell could have been or from where it could have originated.

The family noticed that paranormal occurrences continued to occur whenever they broke one of "Jack's rules." It became quite commonplace. However, Christine was completely unprepared for what would prove to be the creepiest experience to date. Attempting to go on with her life, Christine started to date. As she walked past the bathroom after she returned home from her first date, she heard a loud buzzing sound coming from behind the glass shower door. Cautiously, she opened the door. Inside, she discovered hundreds of big black flies. What struck her as odd was that not one of the flies entered the main room; rather, they remained only in the shower. Christine screamed for Kim to grab the bug spray. After receiving no answer, she slammed the shower door and ran to the kitchen to retrieve it herself. Her daughter met her halfway. Armed with the bug spray, they prepared for battle in the bathroom. Kim opened the shower door for Christine, but there were no flies to be found. The flies had disappeared as mysteriously as they had appeared.

Approximately one year later, Christine sold the house. Since then, it has been on the market several times. It seems no one chooses to stay there for very long. What does Christine think? "I think it's truly haunted, and people are scared to be there."

A True Mystery

Sometimes the most interesting ghost stories come about when you least expect to hear them. While visiting with my friend Heather, she told me about a paranormal account her father, Steve, a retired fireman, had relayed to her when she was a young girl of twelve. Although she is now in her forties, she never forgot the terrifying tale her father shared with her.

In the mid-1980s, the fire department responded to a call that took place on the northeast side of town. Having been told it was a small, contained fire in the kitchen sink, they were surprised to see that a priest had also been called to the scene. It's not uncommon to see a priest at a fire when there has been a death or someone needs last rites, but it is odd to see them when the fire had been contained in such a tiny space. This incident, however, was far from normal.

After the flames were out, they began to walk through the living room to exit the home when a knife came out of nowhere, flew through the air and stabbed itself into the wall between the firemen. Everyone there witnessed the unexplainable event. Unable to determine where the knife came from and who could have thrown it, the firemen felt uneasy and quickly left the house.

During the next few months, the fire department was called back on several occasions to extinguish small fires. With each visit to this home, it became apparent to all who entered that something was not right inside the residence.

Heather's father told her of a couple visits where the firemen witnessed objects moving across the room and sometimes disappearing in front of their eyes. Doors would violently slam shut on anyone walking through the home. During one call, everyone in the home heard the sounds of screaming come from the unoccupied dining room.

This case sounded quite a bit like a poltergeist could be in the home. But can a poltergeist start fires? I decided to do a little research.

One of the earliest accounts of poltergeist activity comes from *Annales Fuldenses Chronicles* describing an event that occurred in 858 A.D. On a farm along the Rhine River, a farmer was the unfortunate victim of poltergeist activity when he and his home were repeatedly pelted by stones. Clergy came to the house to help rid the property of evil forces, but they, too, were pelted with stones. In addition, small fires erupted that destroyed much of the family's just-harvested crops.

Other cases of poltergeist fires include the following instances:

▲ In 1817, the infamous Bell Witch case had several reported spontaneous fires ignite throughout the home by an unseen force. The daughter, Betsy Bell, appeared to be the catalyst of the activity, even though it was her father who paid the ultimate price of death.

▲ In 1882, Dr. L.C. Woodman of Paw Paw, Michigan, followed up on local man A.W. Underwood, who was reportedly plagued by mysterious fires. An investigation followed. Woodman's research and conclusions can be found in the September 11, 1882 *Michigan Medical News*.

▲ In 1890, strange events began to surround an ill fourteen-year-old girl in Thorah, Ontario. While in the presence of her adopted parents, the ceiling suddenly burst into flames. Shortly after this fire mysteriously extinguished itself, another fire broke out in the room. There were numerous unexplained fires over the next couple of

days. This unsettling turn of events made it into the *Toronto Globe* on November 9, 1890. After determining the situation unbearable, the parents surrendered the girl back to the orphanage, and the fires immediately stopped.

▲ In 1958, the Tuck family, a family of eight, resided in a four-room log house approximately eight miles west of Talladega, Alabama. In August, the fire captain realized he had trouble when twenty-two fires inexplicably started, seventeen of them in one day. These fires left the Tuck family homeless and destitute. They were soon given another tenant house nearby, but it wasn't long before the phenomena followed them to their new residence. In front of several government officials, four fires oddly ignited, three on the ceiling and one on a mattress. Fires continued to plague the family as they moved from house to house. One researcher theorized that a "human agent poltergeist" could be the culprit. Despite many investigations by city officials and scientists, no explanations were ever found.

This poor Grand Rapids' family may have been plagued by the same supernatural phenomenon experienced by others in the past. I can't help but wonder if resolution ever came to the family before it was too late.

Lost Residents

When Chuck bought the house near Paris Avenue Southeast, he thought he was getting a great deal. But what he didn't bargain for was the history of the house and the fact that some of the former residents had decided to remain there for eternity.

The first signs of paranormal activity occurred the second night in the home. Exhausted from unloading furniture, he decided to retire to bed early and get some extra rest. Sleep would become a precious commodity that night. After sleeping for two hours, he was awakened by someone walking around on the upper floor. Fearing he had an intruder, he ran upstairs to confront the trespasser. He searched every room but found no one.

Figuring the noise was a product of his imagination, Chuck returned to bed. Soon, he was startled awake by what he described as a metal bed being dragged across a hardwood floor. Once again, he ran upstairs to inspect the rooms but found no one in the house but himself. No other strange

noises occurred that night, but Chuck still wasn't able to fall asleep until the morning's light peeked in through the newly hung curtains.

Over the next few days, the strange incidents seemed to die down, and soon Chuck began wondering if he overreacted to the sounds of mice or the old house settling. He started a new job, and all seemed normal for the next two months.

It was when he began refinishing the hardwood floors upstairs that the activity restarted. He heard a loud and very distinct squealing sound. Searching the upper floor, he was astonished to find the sound coming from behind a little door in the wall. Yanking it open, he found an old dumbwaiter. What was more shocking is that someone or something unseen was trying to use the device, even though a majority of the ropes and chains had been removed. He stood there watching as the gears turned slowly. Chuck slammed the door shut, left the house and stayed at a friend's for the night.

Several weeks later, Chuck's girlfriend Emily decided to research the history of the little home. She discovered that thirty-five years before, the house had been used as a private nursing home. Emily also found several obituaries of people who passed away in the home from natural causes. The reason why Chuck had gotten such a good deal on the home was because no one else was offering to buy it.

After marrying Emily, the couple sold the house at a loss because they no longer wanted the stress that comes with living in a haunted home. He expressed no regret for buying or selling the home, just a great sense of sadness for the unseen residents that have not seemed to figure out how to move on to the afterlife.

CHAPTER 10

HOLMDENE MANOR

Location: Aquinas College

H olmdene Manor has been the haunted focal point of Aquinas College for decades. Gary Eberle, the author of *Haunted Houses of Grand Rapids*, is a professor at this esteemed institution. He has been heard to say on many occasions that he continues to collect ghost stories about this historical landmark to this day.

In order to understand the nature of the haunting, it is necessary first to know the past of this extraordinary manor. Edward Lowe and his wife, Susan Blodgett Lowe, purchased the property on which it sits in 1905. Edward was the grandson of Richard Edward Emerson Butterworth. Together with his wife, Susan, they were responsible for the establishment and funding of both Butterworth and Blodgett hospitals in Grand Rapids, Michigan.

The site of their dream home was originally the sixty-nine-acre McCoy dairy farm located on the former Rathbun property. Construction of their home took place on what was then the outskirts of Grand Rapids. The Tudor-style manor took nearly three years to complete. In 1908, Richard and Susan Lowe, along with their teenage son, Edward Jr., seventeen; daughter, Barbara, fifteen; and young son James, age four, were finally able to move into their twenty-two-room landmark house. They named it Holmdene Manor, after "holm," which is a particular type of oak tree and "dene" which means estate.

The residence was known in town as being the most elegant abode around. In 1911, two years after Theodore Roosevelt completed his term

as president, he visited Grand Rapids for a Lincoln Day address. He stayed as a houseguest of the Lowes and slept in a guest room on the second floor.

While reviewing census reports, it became clear that there were always a great number of people living in the manor. According to the 1910 census, the Lowe family had two live-in cooks, one with a six-year-old daughter listed as a boarder; a housemaid; a waitress; a butler; two chambermaids; a housekeeper; a coachman; a barn keeper; and a launderer. The 1930 census showed that after the Lowe children grew up and moved away from their childhood home, Edward and Susan downsized their live-in help to five servants.

The 1930s brought great heartache to the Lowe family. Susan died on August 4, 1931, at the age of fifty-eight. She passed away peacefully in the garden she adored, a true blessing, as it was one of her favorite places to be. Edward only survived six years without his wife and departed this world to be with her on July 2, 1938.

Less than a year after Edward's death, the Lowe family sold the entire estate to the University of Grand Rapids in 1939. The college used the building for only a few years before it was forced to close due to financial issues during the Second World War.

In 1945, the Dominican Sisters of Grand Rapids, a sect that came to Michigan in 1877 to teach in Catholic parish schools, purchased the property. In 1940, the sisters founded Aquinas College, which was named after Saint Thomas Aquinas, an Italian Dominican priest and philosopher. Having outgrown their downtown college grounds located on Ransom Avenue in Grand Rapids, they moved the main campus to this beautiful estate. Under new ownership, the Holmdene Manor came to serve as both the home of the administration office and additional classrooms for the college.

In 1955, Aquinas expanded its campus and built a new administration building. It was at this time that the manor became the residence of the Dominican Sisters, all of whom taught at the college. In 1980, Holmdene was granted Historic Landmark status. Following this decree, the building underwent a complete restoration. One year later, it was reopened and used as administration and faculty offices.

Hardly a student on campus will deny having heard about the ghostly activity inside Holmdene Manor. However, with just a little research, I was able to prove that part of the story behind the haunting is nothing more than an urban legend.

If you perform a Google search on the Holmdene haunting, you will run across the exact same tales being retold on many different websites. The brief

description of history behind the paranormal activity includes an account of one of the Lowe children drowning in a pond on the estate, while another reference states that one of the sons died in combat.

While examining census records from 1910, 1920 and 1930, it became clear that none of the Lowe children perished by drowning at a young age. I found a death record for James, the youngest child, who died at the age of sixty-five in San Francisco, California. Although unable to locate death records for Edward Jr. or Barbara, it was obvious they did not depart this earth as children. Edward was included in a census at the age of sixty-three, also living in San Francisco. Barbara went on to marry a Frenchman named John Quaintance, and the couple had two children.

The search of historical documents uncovered a ship manifest from October 22, 1931. It showed that at the age of thirty-eight, Barbara traveled from France back to America via New York. I was able to confirm by her burial record that she later remarried Charles Henry Fallas, and both currently rest together in the Lowe Mausoleum.

While I can confirm that no member of the Lowe family was the unfortunate victim of drowning, I am not able to prove that someone else's child did not suffer the misfortune. If it had happened, perhaps to one of the servants' offspring, it would help explain why the sounds of children are the most commonly reported paranormal occurrences at this historical landmark.

There is one thing that remains indisputable with the student body both past and present; it is the fact that this historic building is home to much paranormal activity. Even the Aquinas College Viewbook invites new students to "take part in a ghost tour, as the Holmdene building is rumored to be haunted."

In 2005, demonologist and paranormal investigator John Zaffis visited the Aquinas campus to lecture and tour various haunted sites. Zaffis, most recently known for his show *Haunted Collector* on the SyFy channel, is nephew to the infamous Ed and Lorraine Warren of *Amityville Horror* fame. While visiting the magnificent Holmdene structure, John felt the presence of numerous spirits, including that of one very dominant white woman. He got the impression that she had influenced her black servant to remain by her side in the afterlife, seemingly for eternity. The Lowe family did have many servants employed by them during their time in the manor. Did one of the servants feel such a strong sense of obligation to their former employer that she continued to serve even after death?

Zaffis also reported the discovery of an additional spirit residing in the attic of the manor. He seemed a little put off and refused to give any further

information about the ghostly being during the tour. When pressed, he simply stated, "I'm leaving that one alone." After the excursion concluded, he shared his impression that the spirit in the attic was not one that was welcoming and friendly but rather was an intensely negative being.

The majority of the third-shift campus security officers have had their fair share of encounters, and one incident has happened repeatedly. After painstakingly walking through the building to turn off all lights and lock the doors, the officers return from their rounds of the campus to find the lights on again. One security officer named Dan shared his experience that it is not always necessary to wait for rounds to be completed before the lights are turned back on by the ghostly pranksters. One night after leaving the building, he walked approximately one hundred feet when he turned and noticed all the lights on the third floor were again burning bright!

The third floor seems to be the focal point of light shows, and not just from the electric lights. Several students out for a nighttime stroll have reported seeing greenish-colored lights emanating from the third-floor windows. It is a common belief that these balls of light are energy manifestations in the simplest form.

Residents of nearby Regina Hall have a clear view of the manor. Many of the students report that in the night when the building is unoccupied, they will see lights on in certain rooms of the manor. If they look out their windows later in the evening, they will find the previous lights off and new lights turned on in other rooms.

I received an email from a former student named Eric, an Aquinas College business graduate. He told of a time when he was out for a late-night walk on campus. When he came upon the manor, his curiosity got the better of him, and he decided to sneak a quick look in the ground-floor windows. As soon as he was close enough to peer in, he found he was looking directly at the figure of a young woman standing in the window, staring directly at him. Knowing the building was empty, he was filled with terror and high-tailed it back to his residence.

"I didn't believe all the stories I have heard about the building," Eric stated. "I knew no one was inside that night, but after seeing that woman I will never get near that building again!"

Another account of paranormal activity comes from another professor at the university. She reported that in 2003, she became incapable of staying at Holmdene Manor on the weekends after she was startled by the voices of children, an occurrence often reported in this building.

She stated, "During the week, you are surrounded by other staff members so you don't notice. If you are alone in this building, it is so terribly unsettling and you never know when you will hear the woman or the children."

The sounds of children talking and laughing have been heard both inside and outside near the woods. One possible cause of this laughing could be a residual haunting. The energy of the Lowe children may have been inadvertently recorded in the building materials in much the same way a play is recorded on a VHS tape.

During Halloween 2008, a team of three people conducted an investigation of Aquinas College. Here is an actual account of their investigation:

> *The area around Holmdene was extremely active. We weren't granted access into the building, since we were not an official club or anything. We walked through the woods behind Holmdene, went near the chapel, and back up to the garden area outside of Holmdene.*
>
> *We kept hearing two sets of footsteps coming around us. We prodded with some questions and recorded what we believe to be an EVP responding "yes" to one of our questions.*
>
> *I went around with my digital camera and got one picture with some sort of blue mist-like thing. I tried to identify light sources that would cause it, but I've come up empty-handed. I honestly did not see it when I took the picture, and I did not notice it until someone pointed it out to me.*

Later, the trio of investigators attended a lecture given by Professor Gary Eberle about the history of the college campus. They were excited to learn that they had been standing in the former garden of Susan Lowe when they recorded the unknown female voice. Susan's death is the only documented fatality to have occurred on the Lowe Estate. Perhaps they captured Susan herself answering one of their many questions.

One thing is certain: for those who have had paranormal experiences in this historic building and its surrounding grounds, the spirits that reside in this home will not soon be forgotten.

CHAPTER 11

STRANGE ALGOMA TOWNSHIP

Location: Northeast of Grand Rapids

Algoma Township is located roughly six miles north of Grand Rapids in the northeast section of Kent County. It is approximately thirty-six square miles of green grass and natural forests, accented by the Rogue River. I have already covered the paranormal aspect of Algoma in the "Urban Legends" chapter, as well as offering proof that the popular Hell's Bridge is nothing more than a local myth. What I have not touched on is an interesting fact I became aware of while working with Julie Sjogren from the Algoma Township Committee. This township has had an unusually high level of tragedy for such a small area. I could make a list of all the terrible things that have occurred. To name a few:

- ▲ A gentleman who lived by Pine Island Drive and Rector Street committed suicide.
- ▲ Around the same intersection, a man killed his child and then himself.
- ▲ Just south, another murder/suicide occurred.
- ▲ On Algoma Drive, just north of 13 Mile Road, a twin brother killed his sister.
- ▲ A twenty-eight-year-old man hung himself in a barn.

As we looked at the local map, I was struck by the fact that all of these horrible events took place within a two-mile radius that also encompassed Hell's Bridge and the Rogue River.

I asked Sjogren, "Since the story of Elias Friske was nothing but a fabrication, does that mean nothing similar to the child abductions or murders have taken place within Algoma's history?"

She replied, "Oh yes, there is history of this kind unfortunately," which came as a surprise. I had prepared to hear a denial of anything sinister about the township. Instead, I was schooled on the many tragedies that have taken place there.

Laura Jo Sutliff, a thirteen-year-old girl, was all set to start eighth grade at Sparta Junior High School in the fall. Sadly, she was abducted by knifepoint from the front of her home at 978 Rector Street Northeast on Saturday, July 16, 1966. Despite the many hours that family and volunteers spent looking for her, she remained missing for fifteen agonizing months.

In September 1967, Sonya Santa Cruz had returned to Stocking Elementary School to retrieve a book she had forgotten earlier in the day. On her way home, the seven-year-old disappeared. Weeks later, two horseback riders near Wayland came across her tiny body half-buried in a shallow grave. Upon further investigation, police uncovered a painter's estimate book that had inadvertently been buried with Sonya's school papers under her remains. The book led them to twenty-eight-year-old Theodore Glenn Williams, a local house painter. Upon arrest, Williams asked the police what took them so long.

The Santa Cruz family was horrified. Williams had been considered a family friend and had actually babysat for Sonya's siblings while her mother helped the community search for the missing child. He further shocked authorities when he confessed that he also "got the girl from Sparta." On October 15, 1967, he led them to Laura Jo Sutliff's body, which had been thrown into a shallow grave two miles northwest of White Cloud. Williams was found guilty of both rape and murder. However, before he was sentenced, the conviction was overturned, and he was designated a criminal-sexual psychopath and committed indefinitely to Ionia State Hospital. The law required that he be held until he no longer was a menace to society.

He has spent most of the last forty-five years in mental institutions. The psychopath statute was repealed in 1968; however, Williams stayed confined until 1973, when he and 1,200 others were freed. He was out three months before Allegan County prosecutors charged him with the rape and murder once again. This time he pleaded guilty to second-degree murder and received a life sentence. The state Supreme Court, however, tossed out this conviction as well and ordered his confinement under the defunct psychopath statute.

Despite his claims that he is not the same person he was in the 1960s and the fact that he is, as of now, not convicted of a single crime, the Federal Appeals Court has repeatedly denied him freedom, stating that he has a "mental abnormality that creates a likelihood of future violent conduct." Though I hate to see even a criminal denied their rights, I hope the court's decisions continue to give the victim's families some closure. One thing I do believe is that the world is a likely a safer place with Williams behind bars.

On the chilly morning of February 28, 1861, Daniel Barber, a tax collector, kissed his wife goodbye and set out for work. He had to make his way into Grand Rapids to turn over the $600 he had collected to the county treasurer. William Kingin, another local man, accompanied him so he could break a $50 gold piece and pay his taxes. Together, they set off. Three hours later, men on sleighs came across the lifeless body of Barber on Reynolds Hill, the second hill between Laphamville and Plainfield. He had a two-inch long gash behind his right ear where brain matter was protruding. He had been struck eight times in the head with what appeared to be an axe. Several men began to search the area for the weapon. They found it embedded in the snow approximately fifty yards from the path. The head of the axe was discolored by blood and had pieces of hair stuck to it.

Several people had witnessed Barber and Kingin walking down the sleigh path earlier that morning, and Kingin had been seen carrying an axe. He was immediately arrested. During the trial, Kingin showed great remorse, with tears streaming down his face. He confessed to the murder, saying that he had been overcome by a spontaneous frenzy of greed. Prior to this point in his life, he had been a gentle, law-abiding citizen. He was given a life sentence and was an apologetic, model prisoner up until his death.

Thomas Kapuscinski and his wife, Delores Graham, married in 1969. They settled in a house just north of Rockford, where Thomas began to work as a forklift mechanic. During the early morning hours in February 1987, a call came into police dispatch. Delores reported that an intruder had broken into their home and shot her husband twice in the head as he lay sleeping. Detectives soon began to notice that the clues did not match her story. Then they found a .22-caliber rifle that belonged to Thomas shoved underneath the couch.

Knowing she had been caught, Delores confessed that she had intended to commit suicide in the basement but somehow wound up shooting her husband instead. She claimed he was an emotionally abusive man, a statement that his family vehemently denied. Investigators easily found her motive for murder: Delores was in financial trouble, and her family was about to be

Children's rendition of the Hodag. *Courtesy of Algoma Township Historical Museum.*

evicted for defaulting on the mortgage. Her husband's life insurance policy stood to net Delores $200,000. She was convicted of first-degree murder and sentenced to life in prison without the possibility of parole.

Algoma Township has not only had an abundance of suicides, murder and child abductions, but we can add one more oddity to the mix: cryptozoology. Cryptozoology is the study of animals that are not recognized by the scientific community but have been reported by witnesses.

A big part of Algoma's history is derived from lumber mills. The loggers would use the Rogue River to help transport their wood. It was during this logging era that a creature made its introduction into Algoma's history. Word quickly spread throughout the logging camps that a mysterious creature had been seen running around the swampy area near Friske Drive and 12 Mile Road.

History and Directories of Kent County briefly mentions this mystic creature, stating:

> *There is a portable detached steam saw mill on the west side of section eleven, erected in June 1869, by McClure & Kidder. This mill cuts 10,000 feet of lumber, or 15,000 shingles per day. It will be better known as the Hodag mill. This name was given it, from the fact that an unknown and mysterious animal was heard, seen and even fired at, in the woods near here, some years ago, and as no other name could be found for it, it was called Hodag and when the mill was built, this was the name given to it by the people.*

Armed with sketchy descriptions of what the Hodag looked like, the Algoma Township Historical Society created a children's contest to come up with the best drawing of this elusive Hodag from the 1800s.

When teenage thrill seekers venture out to Hell's Bridge in hopes of experiencing something paranormal, they do not need to worry about the untrue legend. Instead, maybe they should be concerned about running into the vengeful spirits of victims from Algoma's past, all the lives that were cut short by violence. One last thing for them to think about is that perhaps the Hodag is not a mysterious creature from the past, but one that continues to roam the woods and swamps near 12 Mile Road to this day.

CHAPTER 12

SPIRITS OF A DIFFERENT KIND

Location: 36th Street Lounge, Wyoming, Michigan

When I began to spend more of my free time in Grand Rapids, I found myself looking to try out some new places. A friend of mine highly recommended a small bar and restaurant called the 36th Street Lounge, formerly Lennie's Place, for two reasons: the first was that locals claimed it had the best burritos in town, and the second was that he knew I was always looking for a good haunted location to write about.

On a previous visit to the restaurant with his family, my friend had overheard a conversation between two of the workers arguing over which one of them was going to go down to the storeroom to fetch the stock. Neither of them wanted to go, especially by themselves.

During my first visit to this charming, small business, I prodded the server with my usual lead-in: "I heard from a friend that this place could be haunted." Without hesitation, my server looked directly into my eyes and whispered, "The basement." Without her knowledge, she had confirmed the basis of the overheard conversation that had taken place a year earlier.

As word spread around the lounge that I was interested in the paranormal, several members of the staff stopped by my table to share their personal experiences with me. They all seemed to genuinely believe something out of the ordinary was going on in their workplace. After I finished my amazing plate of fettuccine, the manager granted me permission to take my own trip downstairs to shoot some photographs.

The basement of this facility, which has come to be known as the Rock Room, features local bands on the weekends. It consists of a modest dance floor, bandstand, small bar and multiple couches where patrons can relax while enjoying the live entertainment.

What struck me as odd is that the workers didn't even give a second glance toward the outsider walking around taking photographs of nothing in particular. It was as if my presence was not a surprise to them, as if they had seen it all before.

I introduced myself to another staff member named Bonnie. I asked if she had ever witnessed anything out of the ordinary. She told me that within the past year or so, several of the bar's employees had dabbled with their own amateur ghost hunt in the basement area after someone had brought in a Ouija board that they used to hold a séance. It became clear to me that the reason no one seemed curious about my presence in the basement was because I wasn't the first person who had done this; most everyone that worked there believed someone or something unseen was down there.

After I finished taking photographs and my walkthrough of the basement, Bonnie and I headed upstairs. As we walked, she told me that her co-workers claimed a night manager had been brutally murdered in the basement. Thinking this could just be a restaurant urban legend, I mentally put it on the back burner until I could research it further. I thanked all the employees and the owner of the establishment for their generous hospitality and delicious food and went on my merry way with visions of research dancing in my head. I had no idea what I would find.

After spending hours combing through the local history section of the library, I came across an article about the murder of the previously mentioned employee. On Saturday morning, July 13, 1996, a staff member arrived to work at Lennie's Place and found the body of thirty-one-year-old nightclub manager Richard Allen Morris. Morris was a father, as well as a firefighter with the Wyoming Fire Department. He had only worked at Lennie's for two weeks when he was shot and killed by a single gunshot wound to the head. This happened in the manager's office, a room that was—coincidentally—in the basement. At first, the Wyoming City Police Department suspected this was an open-and-shut case of a robbery gone bad, but they would soon uncover the full story that led to this cold-blooded murder.

After seven months of investigation into this horrible deed, the police were able to arrest the gunman, Ricardo Demone Malloy, age nineteen. He was detained and charged with one count of open murder, commission of a felony with a firearm and robbery for the murder of Morris in July 1996.

In March 1997, the police made two more arrests in connection with the killing. The suspects were Chauncy Mahone, sixteen, and Cody Jerome Skaggs, seventeen. They were both taken into custody and charged with the same felony murder and robbery charges that had been given to Malloy.

During the investigation, it was discovered that Cody Skaggs had worked at Lennie's Place as a cook and had been fired two weeks prior to the murder. His mother had also worked at Lennie's as the manager for fourteen years—until recently, when she had been replaced by none other than Richard Allen Morris. With this new information in hand, the apparent motive of robbery began to look more like a revenge killing.

After interrogating the three suspects for hours, details of the plot came to light. Skaggs had the idea to rob the place and enlisted the help of his two good friends. They claimed the robbery was to take place afterhours when no one was there. Malloy carried the gun because Skaggs and Mahone were concerned the bar's employees would recognize them if they were seen.

During their confession, they told of the night's events. They had waited outside for the patrons and support staff to leave. When all looked clear, they broke into the building and went down to the manager's office, where the money was kept. It was there that they were confronted by Morris. Malloy fired the gun, but the initial shot missed, sailing over Morris's head. A second shot was immediately fired, and this one hit its mark: Richard Allen Morris's temple. Mahone grabbed the coin box that contained approximately $700, and they all ran off.

Cody Skaggs, the mastermind of this murderous plot, was not just an innocent teen who had one night of bad judgment; he had a long history of trouble. His rap sheet started when he was only thirteen with breaking and entering into a motor vehicle. In the years that followed, his actions became increasingly violent. He was expelled from Ottawa Hills High School for pulling a knife on another student. By the age of sixteen, he had been kicked out of a juvenile correction program. He was convicted of retail fraud, theft, possession and use of a firearm while fighting. He also committed armed robbery of a patron at an ATM and managed to remove an electronic tether designed to track his movements.

At some point during Skaggs's crime spree, the court deemed his mother unfit to raise him, and he became a ward of the state. He was placed in, and ran away from, many foster homes. Even at her son's sentencing hearing, it seemed as though the mother did not fully comprehend the actions of her son, saying, "You'll never hear our family say one bad word about Cody. My son is not a terrible person."

On the other side of the courtroom was Janice Morris, the mother of the victim. She had, in fact, known the defendant Cody Skaggs since he was a small child. Upon hearing of her son's misfortune, she had no doubt that Skaggs was somehow involved.

After months of hearings, it was time for judgment to be passed. Malloy and Skaggs were allowed to plead guilty to the lesser-included charge of second-degree murder and received sentences of twenty-five to seventy-five years in prison. Mahone was charged as an accomplice and received a ten- to fifteen-year sentence.

All of the paranormal activity cannot be attributed to the death of the former manager, however. I was fortunate enough to interview several employees, both past and current, while gathering the facts on this case. Many of the people we spoke with acknowledged seeing an unknown female apparition wandering around the basement from time to time. While researching the property, nothing was uncovered that could help identify any historical reason for her presence. Several employees did admit to using a Ouija board in the building. Subsequently, the woman could be any one of a

Area where female apparition is spotted coming down the stairs. *Photograph by Nicole Bray, 2011.*

number of souls present in the spirit realm that decided to stop in and chat while this supernatural portal of conversation was in use.

One employee, Beth, had been working alone in the basement and turned around just in time to witness a female walking down the back stairs and into the small bar/kitchen area. Since she did not recognize the woman, Beth followed her into the kitchen to inquire why she was present in a closed-off section of the restaurant. Upon entering the very same room, she was stunned to find it empty. "I knew then I had witnessed a ghost. She did not walk past me to leave the room, and she sure did not climb out of the open service window and on to the dance floor. She just vanished!"

Heather, a former bartender, related her tale of grabbing stock from the back cooler. While doing inventory on the beer supply, she felt someone tap her shoulder. Assuming it was her co-worker, she didn't turn around; she simply asked, "What?" Getting no response, she continued on with her duties. Seconds later, she was tapped on the shoulder again. Irritated, she spun around to find out just what the person needed. Only one problem—no one was there!

A former manager shared her strange tale of the time she saw a man walking through the lobby after the business had closed. Suspecting a drunken patron was still roaming the building, she sent the bouncers to find and remove him. She was quite surprised when the bouncers returned and told her that they had looked everywhere but had found no one else in the building.

A current staff member by the name of Jen was kind enough to share an experience she had during an opening shift at the restaurant. She was startled when she heard her name being called from behind her. What made this especially unnerving was that she was the only person, alive anyways, in the entire building.

Other strange occurrences include voices and unknown knocking noises coming from the pint cooler, a strange sound resembling a bowling ball being dropped and rolled across the stage area and lights that turn on and off at random times while no one is near the switches. There was even an incident where a huge pot of spaghetti overturned itself while sitting flat on the floor.

Since I am not a fan of Mexican food, I never did try the 36th Street Lounge's burrito entrée. I was pleased, however, that I had visited this tavern as it definitely has its share of unseen patrons.

CHAPTER 13

LETHAL LOVERS

Location: Walker, Michigan

As an author and paranormal investigator, I am often asked questions about the supernatural. The most common thing I am asked is, "Rob, if I am in a haunted place and there are ghosts around me, why have I never seen one?" My answer is always the same, "No one knows the answer to that. Maybe you're not looking in the right place, or maybe you're just not looking at things the right way." In the late nineties, several years into my experience as a paranormal investigator, I worked in a location that has been the site of many paranormal reports. Unbeknownst to me, I was employed in what had been the site of at least five murders. However, in the months I was employed there, I was blissfully unaware of the paranormal activity, despite knowing what to look for. If only I had known, I would have managed to sneak in an EVP session or two!

Most consider Aileen Wuornos to be the first American female serial killer after she murdered seven men in Florida in 1989 and 1990. A little-known fact is that Grand Rapids was once home to two women whose murderous spree predated the infamous Wuornos. Their names are Gwendolyn Gail Graham and Catherine May Wood, better known as the "Lethal Lovers." They had perpetrated their crimes on the grounds of the Alpine Manor Nursing Home in Walker, Michigan.

Gwendolyn Graham and Catherine Wood met in 1986 when Cathy, a recently divorced and depressed obese woman, was hired as a nurse's aid.

As fate would have it, Gwen was her direct supervisor. In no time at all, the two women became close friends and eventually lovers. The couple practiced various forms of sodomy while pleasing each other, but according to interviews with both women, their favorite practice was erotic asphyxia. During this activity, one partner dominates the other, smothering or strangling their submissive partner, close to the point of losing consciousness. When asked to describe the practice for Court TV, author George Shuman was quoted as saying, "When the brain is deprived of oxygen, it induces a lucid, semi-hallucinogenic state called hypoxia. Combined with orgasm, the rush is said to be no less powerful than cocaine and highly addictive." This dangerous thrill, however, soon proved to not be enough for the couple's devious sexual appetites. They conjured up another, more deadly game that used the home's patients as pawns. This time, killing the patients at the nursing home was their aphrodisiac.

In late 1986, Gwen attempted to take the life of several female patients by smothering them with a washcloth. She was unsuccessful as the seemingly frail victims were able to find the strength to fight off her attack. Afterward, the patients reported the assaults to the staff. If someone had only listened to their stories, the tale may have ended there; unfortunately, it does not. In January 1987, Gwen revised her modus operandi. She would only attack victims who were too incapacitated to fight back; more often then not, she found this trait in women suffering from Alzheimer's disease. While Cathy stood guard, Gwen would slowly smother the patient, who was chosen not only because she didn't have the strength to fight back but also because of her name. The murderesses planned to kill victims whose initials would collectively spell out the word M-U-R-D-E-R. These deadly games sexually excited the couple so much that they would sneak into an unoccupied room and make love to each other.

The murdering duo was not shy about their chilling practices and bragged openly about the murders. On a few occasions, Gwen even showed her collection of souvenirs to her co-workers. Composed mostly of jewelry and dentures, the morbid museum was housed on a shelf at work where she could visit them often and relive the murders. An article from the *Grand Rapids Press* published on September 19, 1989, explains that even though the couple often boasted about killing six patients, none of their co-workers took them seriously. All in all, the pair was loved and respected by the residents.

Sometime after the last murder on April 7, 1987, the couple broke up. This split was reportedly due to Cathy's refusal to take a more active role in

the murders. To avoid pressure from Gwen to perform a solo murder, Cathy asked to be transferred to another shift.

Gwen returned to her hometown in Texas with a new lover, Heather Barager. Barager would later testify in court that she and Gwen had moved to Texas to escape threats made by Cathy. Cathy had warned that she would "take Gwen away and put her in prison forever and a day," if Gwen didn't end her affair and return back to Michigan.

Instead, Gwen found new employment in Texas at Mother Frances Hospital, taking care of infants. During telephone conversations with Cathy, Gwen spoke of the growing desire to kill the babies. In a *Grand Rapids Press* article from September 15, 1989, Cathy is quoted as saying, "When she was killing people [at Alpine Manor] and I didn't stop it, it was bad enough. But when she was in Texas, she said she wanted to smash babies. She worked in a private hospital and told me she liked walking past the nursery and wanted to smash them."

Overcome by guilt and in constant fear that Gwen would soon start to kill innocent babies, Cathy made a full confession to her ex-husband in August 1987. He didn't go to the police until fourteen months later to file a report, which launched an extensive investigation. Authorities learned that during Gwen and Cathy's three-month killing spree, forty deaths were reported at the Alpine Manor. Investigators believed the women were responsible for at least eight of those deaths but were only able to gain enough evidence to prove five of them.

In December 1988, both women were arrested and charged with murder in the first degree and conspiracy to commit murder. Cathy Woods turned states evidence and pled guilty to conspiracy to commit murder as well as the lesser-included crime of second-degree murder of one of the victims. Due to Cathy's cooperation, Gwen Graham received six life sentences. As arranged in the plea bargain, Cathy was sentenced to only twenty to forty years in a federal prison where she has been eligible for parole since March 2005.

As of 2013, Gwen is serving her life sentences in the Women's Huron Valley Correctional Facility located in Ypsilanti, Michigan. Cathy is incarcerated in the minimum security Federal Correctional Institution in Tallahassee, Florida. It is considered unlikely that Cathy will ever make parole despite her cooperation with authorities. Her release date is currently set at June 6, 2021, when she will be fifty-nine years old.

The building has since been renamed and remodeled. The murderers are locked away, and everyone who knew them have either passed away, changed jobs or retired. Even with all these changes, the spirits of the victims continue to

reveal themselves to staff members. There have been multiple spirit sightings of elderly women struggling to hang on to their lives. A friend of mine, a professional psychic, was overcome with panic when she was visiting a relative who resides in the current nursing home. One of the best stories about the former manor was written by a former nurse named Mary on the currently defunct Ghost Zoo website (www.ghostzoo.com). Her tale goes as follows:

I started working at the nursing home intending to only work there for a few months until I could take my boards. The place was a wonderful place to work and all the residents seemed to be genuinely happy, well almost all of them. There was one resident who I will call Sue that went from happy to terrified overnight. The night of the change, she suffered a fall and temporarily lost consciousness. I was called to her room and checked her over and did a complete vitals check. Then as required by policy, I called her doctor and her family. All appeared to be ok. The doctor saw no signs of serious injury and the family was satisfied it wasn't the fault of the nursing home that she had fallen. All was fine until that night.

That night Sue began to scream at the top of her lungs that her new roommate was being hurt. The problem with this statement was that since her husband had passed away she hadn't been given a new roommate. I called her doctor and was given an order to administer a sedative and told he would be in to check on her in the morning. The morning came and the doctor once again checked on Sue. He ordered some tests at the local hospital and she was picked up by her family and taken to the hospital so they could be run.

She returned the next day with a clean bill of health. However, that night she started to scream once again about her roommate being hurt. I told her she didn't have a roommate and she replied "I sure do, her name is Myrtle!" I wrote this information down and once again contacted the doctor. He once again ordered a sedative but this time told me something I would not soon forget. I was informed by the doctor that Myrtle Luce had been one of his patients there a decade earlier, and that she had been in the same room now used by Sue. He then informed me that Myrtle had been murdered. I went to Sue's room, gave her the shot, and then called the D.O.N. (Director of Nursing) to inform her I was ill and needed to go home. I never returned to work there.

Paranormal experts believe that victims of murders and suicides can remain trapped at the location of their death for many reasons. Some theories for this include:

▲ The soul of a victim that experienced a violent death might not be able to rest if they feel justice has not been served.

▲ Some people might have died so suddenly that their souls are not aware they have passed on.

▲ It could be a residual haunting, in which the energy or imprint from a traumatic event is replayed over and over, much like a video recording.

To the observer, it is not likely going to matter if the ghost they see is interactive or simply a residual haunting. To many people, the idea of being in the presence of any ghost is terrifying, no matter what the cause. The institutions where life is often lost in a moment seem to hold an unproportional amount of activity. Most parapsychologists believe that we are more likely to experience spirits around us when we are youngsters or in the final years of our lives. If so, it is no wonder so many nursing homes are reputed to have otherworldly residents.

BIBLIOGRAPHY

Ancestry.com

Bell, Sasha. "Kent County's Ada Witch." August 26, 2010. http://suite101. com/article/kent-countys-ada-witch-a278963.

Dillenback & Leavitt. *History and Directories of Kent County.* Grand Rapids, MI: Daily Eagle Steam Printing House, 1870.

Eberle, Gary, and John Layman. *Haunted Houses of Grand Rapids.* New Zealand: Silver Fox Pub, 1993.

Etten, William J. "Citizen's History of Grand Rapids." A.P. Johnson Co., 1926. http://kent.migenweb.net/etten1926/index.html.

GenealogyBank.com

"The Ghost of Elias Friske." http://www.hauntspot.com/haunt/usa/ michigan/hells-bridge—the-ghost-of-elias-friske.shtml.

Grand Rapids Herald.

Grand Rapids Historical Society. "A Brief History of Grand Rapids." http://www.grhistory.org/id22.htm.

Grand Rapids Press.

"Haunted Aquinas College." http://www.michigansotherside.com/ articles/Aquinas.html.

"Haunted Places in Michigan." http://www.theshadowlands.net/places/ michigan.htm.

Heritage Hill Association. http://www.heritagehillweb.org/tours-of- heritage-hill/self-guided-walking-tour/; http://www.heritagehillweb. org/about/history/.

"Murder of the Beautiful Typist." *True Detective Magazine*, November 1938.

"Phillips Mansion." http://www.hauntedhouses.com/states/mi/phillips_mansion.htm.

Schock, David B., PhD. DelayedJustice.com.

SeekingMichigan.com

Shuman, George D. *Last Breath: A Sherry Moore Novel*. N.p.: Pocket Star Pub., 2007.

Strickler, Lon. "Firestarter: Accounts of the Phenomena." May 21, 2009. http://naturalplane.blogspot.com/2009/05/firestarters-accounts-of-phenomena.html.

Taylor, Troy. "The Alabama Fire Poltergeist." http://www.prairieghosts.com/al_fire.html.

Vann, Father Joseph, ed. *Lives of Saints: With Excerpts from their Writings*. New York: Crawley and Company, 1954.

"Vortex." Unexplained Mysteries. http://www.unexplained-mysteries.com/viewarticle.php?id=190.

Wagner, Stephen. "Scariest Poltergeist Activity." http://paranormal.about.com/od/poltergeists/a/Scariest-Poltergeist-Activity.htm.

ABOUT THE AUTHORS

Julie Rathsack became interested in ghosts at an early age. At ten years old, she began experiencing unexplainable activity in her home: objects moving, shadows, voices, etc. This prompted her to collect anything she could on the subject. In 2003, she officially joined the West Michigan Ghost Hunters Society. Today she is vice-president and research director. Julie is a graduate of Grand Rapids Community College (GRCC), where she earned an associate's degree in liberal arts. Julie resides in Grand Rapids with her husband, Dave, and their two sons.

Nicole Bray was surrounded by the paranormal world when at a young age she moved into a haunted house in Ionia, Michigan. Her quest for knowledge grew throughout the years until she formed the West Michigan Ghost Hunters Society in 1999. Nicole's passion for the paranormal opened other opportunities, such as co-hosting WPARanormal Talk Radio in 2005 and co-authoring of the *Paranormal Michigan* book series in 2008.

She is a mother of four children and a grandmother of two little girls.

Reverend Robert Du Shane is the founder of WPARanormal Incorporated. He grew up in a Portage home where seeing the specters of Indians roaming about was almost a nightly occurrence. Robert never suspected at the time that the spot where his house sat was once the site of a major Indian massacre. Robert's interest in the paranormal flourished, and in 1993, he founded what would later become Michigan's first incorporated

paranormal investigation team, and that was followed by the creation of WPARanormal Talk Radio in 2003. Robert was ordained as a minister in 2001 and is the father of two children, one of whom just provided him with his first grandchild earlier in 2013.